Mark Crilley's Ultimate Book of Drawing Hands

Mark Crilley

IMPACT

IMPACT

An imprint of Penguin Random House LLC
penguinrandomhouse.com

ISBN: 9781440353482
eBook ISBN: 9780593327999

Printed in China
10 9 8 7 6 5 4 3 2 1

This book is dedicated
to my wife, Miki,
who took me by the hand
and led me into a happier life

Contents

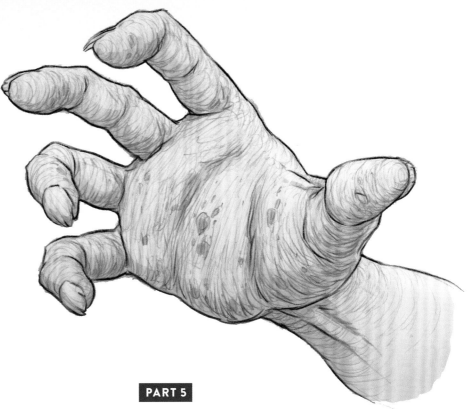

Introduction

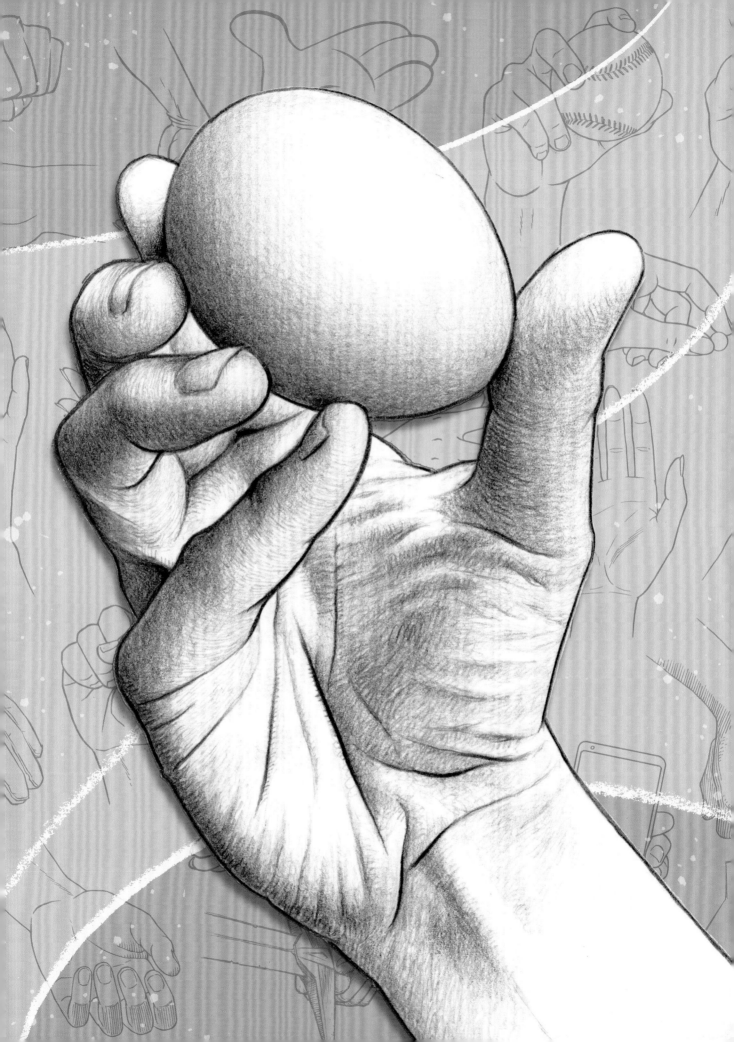

What You Need

Many instructional art books begin with a laundry list of art supplies you need to buy before you can begin following any lessons. Not so with this book. All you need to get the most out of these lessons is three simple things, and you may well already have them in your home right now: paper, a pencil and an eraser.

Paper

This is not a book about creating finished pieces of art that can be displayed in a museum. It's all about practicing: gaining knowledge that can be applied later on to any art form in which drawing hands is a necessity. Pretty much any paper you have on hand is good enough for the job.

Indeed, some of you may prefer drawing on a computer tablet. If that is the case, then go for it. The "virtual paper" of an iPad or similar device is just as good as real paper when it comes to following this book's lessons.

Pencil

I recommend using a pencil for these lessons rather than a pen, simply because most of the step-by-step lessons require a bit of erasing, here and there. As for which type of pencil you should use, my advice is to try a number of different pencils and find the one that works best for you. A pencil with super-soft graphite is easily smeared, while a pencil with super-hard graphite may produce only a faint line on the paper. Find a pencil that you feel is a good balance between these two extremes.

Eraser

Many writing pencils have a small eraser attached to the opposite end, and I find this is more than sufficient for drawing practice. That being said, these sorts of erasers age over time, eventually becoming hard and dry. Make sure that the eraser you're using is fresh enough that it erases lines cleanly without leaving any marks behind.

If you prefer using a large eraser that is separate from your pencil, by all means do. When it comes to drawing practice, my advice is to use the tools that you are comfortable with, and only you can say for sure what those materials are.

Drawing a Thumb

Let's get started with a little practice lesson. This will help you get used to the step-by-step method I'll be using for the rest of the book.

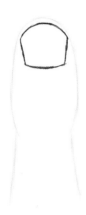

The Tip of the Thumb
Begin by drawing the tip of the thumb using a single curved line that looks a little like an upside-down letter U. Pay attention to how tall it is compared to how wide it is.

The Base of the Thumb
Add two vertical lines to serve as the contours of the base of the thumb. Note that they have a slight diagonal tilt to them, resulting in the two lines being more widely spaced at the bottom than at the top.

The Thumbnail
Draw the thumbnail near the tip of the thumb. The top of this shape is quite rounded, while the line along the bottom is almost a simple horizontal line. The lines on the right and left tilt outward as they reach the tip of the thumb.

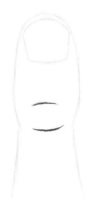

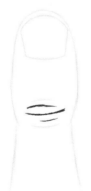

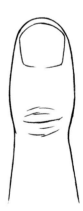

The Knuckle Guidelines
Draw two curving horizontal lines to indicate the area of the wrinkle. When drawing these two lines, pay attention to how far apart they are, as well as how much blank space there is between the top line and the bottom of the thumbnail.

The Knuckle Wrinkles
If you'd like a bit more detail, try adding two or three more wrinkle lines to the knuckle. Take care to keep all these wrinkle lines a bit light, as such lines are quite subtle in real life.

The Finished Drawing
You did it! If any of your lines still look a little rough, go in with your eraser to clean things up. If you were able to follow all the steps in this lesson, you're in good shape to proceed to the more ambitious lessons in the pages ahead.

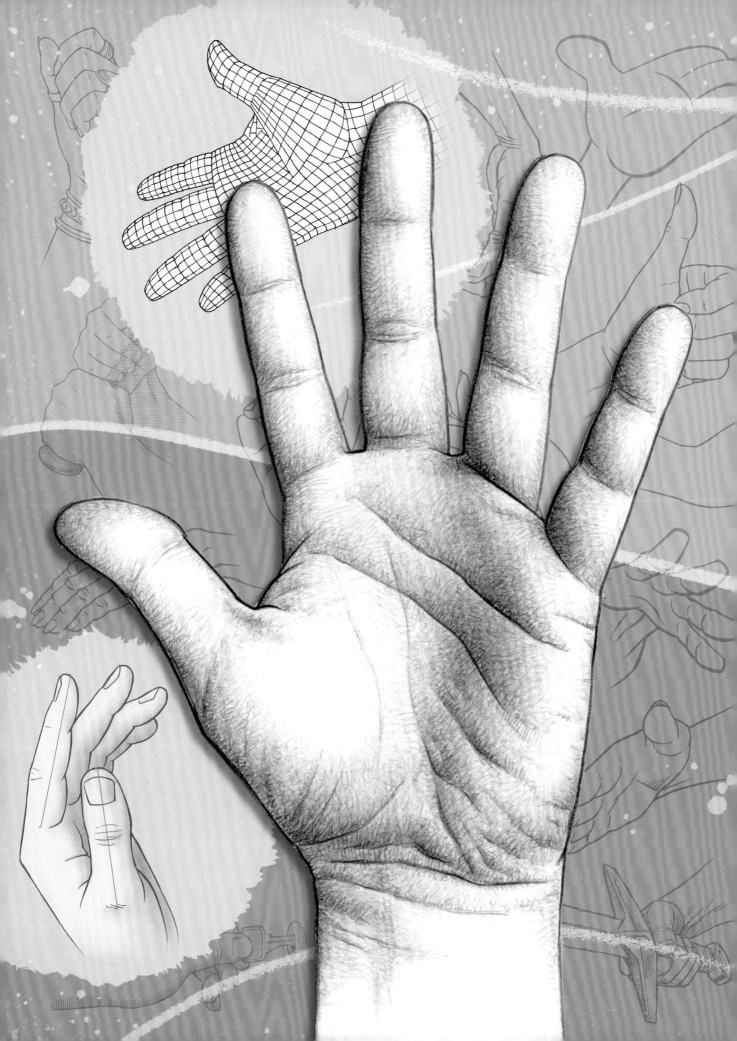

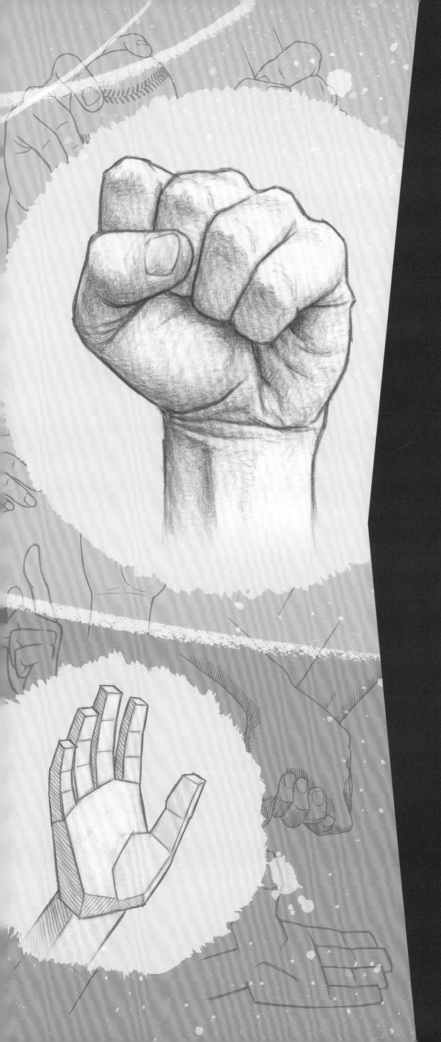

The Basics

In order to draw hands well, you need to have an understanding of the human hand's fundamental structure. That's why I've devoted most of this first chapter to helping you become familiar with the basic parts of the human hand and how they relate to one another. By following the step-by-step lessons that lay ahead, you will gain the knowledge you need to begin drawing hands more accurately.

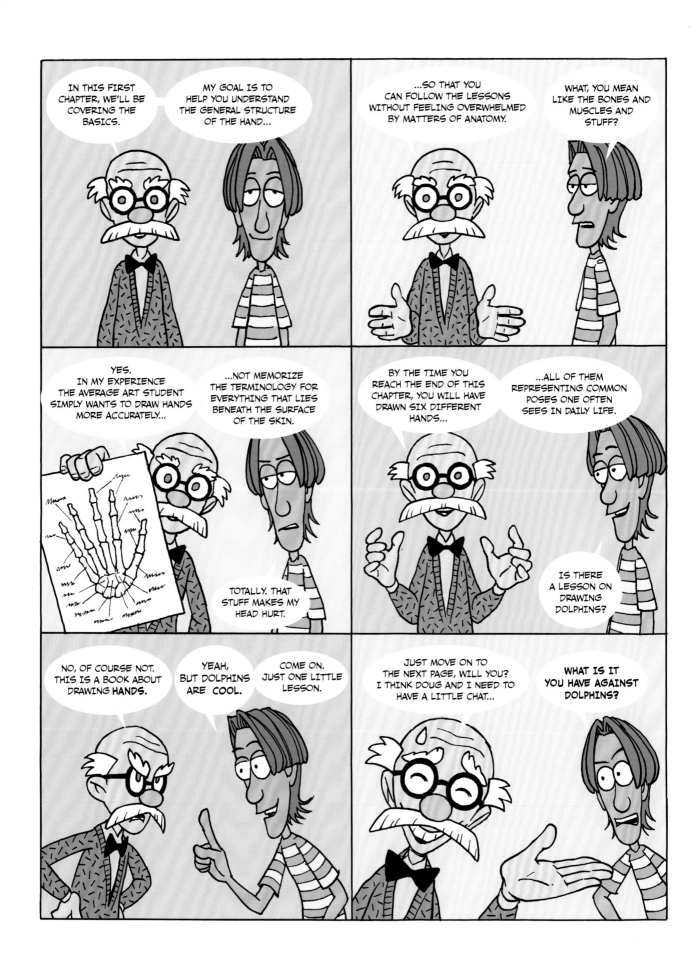

The Parts of the Hand

In order to draw the human hand well, you need to familiarize yourself with its basic parts. In this drawing I have separated these parts—the fingers, thumb and palm—one from the other, to help you understand them more clearly.

The Fingers

We all know that the human hand has four fingers, but have you paid attention to their various lengths? Here you can see that the middle finger is the longest one, while the index finger and the ring finger—equal to each other in length—are slightly shorter. The pinky is substantially shorter than the others (and narrower in width as well). Memorizing these four finger lengths is essential to drawing hands well.

The Thumb

While the fingers divide into three subsections called *phalanges*, the thumb divides into just two. The thumb itself is thicker than any of the fingers, especially at its base near the palm. The tip of the thumb tends to tilt back and away from the rest of the hand, even when the hand is at rest.

The Palm

It can be helpful to think of the palm as a squarish shape, its boxy contour interrupted only by the base of the thumb. Note that the area where the fingers join the palm has a gentle curve to it, sloping downward as it reaches the base of the pinky. There is a concave area in the center of the palm, resting between two "meaty" structures: a large one at the base of the thumb and a smaller one extending from the wrist to the pinky.

The Open-Palmed Hand

For this first step-by-step lesson, I've chosen a simple open-palmed pose that allows you to see the full structure of the hand. Completing this drawing will help you memorize the proportions of the hand and how the various parts fit together. If you've never managed a decent drawing of a hand before, well, get ready: I predict you're going to do one, right now!

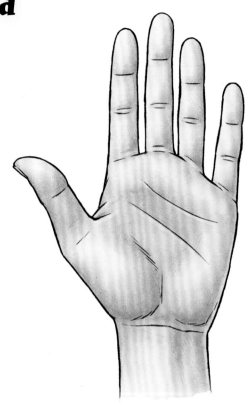

1 The Palm and Wrist
Begin by drawing the shape of the palm, keeping your lines light so that you can erase them later. Note that this boxy shape is slightly taller than it is wide. The lower-left corner of the box is clipped off by a short diagonal line: the beginnings of the base of the thumb. Once you've got this shape in place, add two vertical lines at the bottom for the wrist.

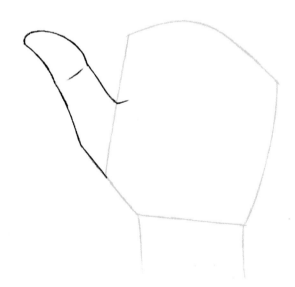

2 The Thumb
Add the thumb. Extend the diagonal line from step 1, then add the basic contour of the thumb, which is divided into two chunky sections. The tip of the thumb is rounded and curves back slightly, away from the palm. Pay attention to the exact location where the upper contour line crosses over into the area of the palm: it's pretty close to the exact middle.

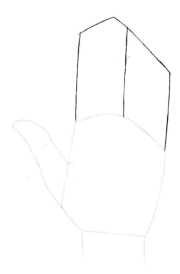

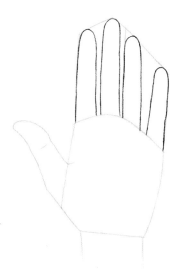

The Finger Guidelines

Drawing the individual fingers is for many people the hardest thing about drawing hands. It can be helpful to lay some groundwork with a few simple guidelines. Here you see a houselike shape with a vertical line up the middle, designed to ensure good proportions for each individual finger in the next step. Note that the tip of the "roof" is shifted off to the left, and that the height of this whole shape is similar to the height of the palm shape you drew in step 1.

The Fingers

This is the trickiest step, so take your time. Begin by drawing the index finger on the far left side of the house shape, giving it a gently rounded tip. Next draw the middle finger, leaving a small gap between its contour on the right and the vertical line you drew in step 3. Now you can draw the ring finger, making its left contour follow right along that same vertical line. Finally draw the pinky, leaving a substantial gap between it and the ring finger.

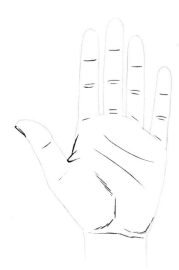

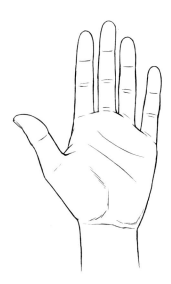

The Details

Now we can add details to the drawing. Begin by drawing thin horizontal lines on each of the fingers, dividing them into thirds. Then draw wrinkles at the base of the thumb where it connects to the palm. Finally, add an indication of the thumbnail, just barely visible from this point of view, and a few lines near the wrist to delineate the structure of the palm in that area.

The Finished Drawing

If any remaining guidelines from steps 1 and 3 are still visible, erase them now, so as to leave only the final line art visible. Congratulations! You've drawn a darned good-looking hand.

A Hand at Rest

When a person stands with their arms hanging loosely at their sides, their hands fall naturally into a relaxed-looking pose—one that requires no effort at all to maintain. Drawing such a hand is quite a different matter, though. It requires quite a lot of effort indeed! Never fear. This lesson will take you through the process, step by step.

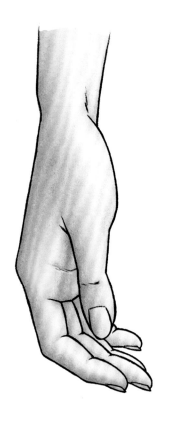

1 The Palm and Thumb

This hand pose is most often seen from the side, with the palm and the thumb joined together to form a single, integrated shape. Begin by drawing the long vertical line you see on the left, giving it a slight tilt to the right. Then draw a curving line on the upper right to delineate the base of the thumb. Now you can add the shape of the thumb itself, taking care to draw its tip with a single, gently curving line.

2 The Wrist

Add two lines at the top of this shape to form the contours of the wrist. Note that the mass of the base of the thumb causes it to extend out from the lower side of the wrist. Artists convey this structure by having the line at the base of the thumb pass in front of the contour line of the wrist. In this location you can see I've added a few short lines to farther convey the structure in this area.

The Finger Guidelines

Once again, it is helpful to get some preparatory line work in place before attempting to draw the fingers. At this stage I often draw a single shape that represents all the fingers at once, as you see here. The key is to focus on the angles of the lines and on the size of the curved shape that they form. This shape should be nearly as large as the palm itself.

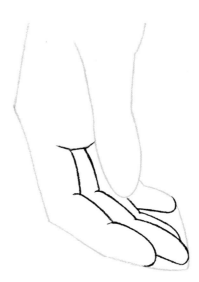

The Fingers

Take this shape and carefully divide it into the four individual fingers. Begin with the index finger, as it is the one we can see in its entirety. Note the subtle angles of each phalange, each one bending just slightly as the finger extends from the palm. Next you can move on to drawing the middle finger, the ring finger and the pinky, each of them echoing the shape of the index finger.

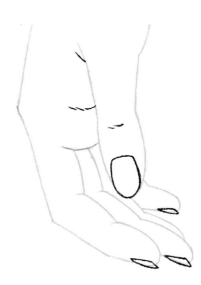

The Details

You're nearly done. Draw the thumbnail on the thumb, taking care to have its shape fit snugly into the thumb shape you drew in step 1. Next add nails to the fingers. Since we see them only from the side, they can be rendered as narrow, sliverlike shapes. Finally, draw a few wrinkles in the area of the palm to show the puffiness of the flesh in that location.

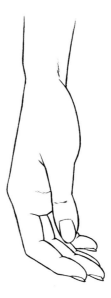

The Finished Drawing

If there are any remaining guidelines from steps 1 and 3, take a moment to erase them now. There you have it: a hand that's just hanging there, relaxed. If only it were as easy to draw as it is to do!

Envisioning the Hand

A huge part of improving one's ability to draw hands is being able to envision the human hand in three dimensions. Every artist arrives at their own way of doing this. Here are three methods that may work for you, and the goal of all three methods is the same: to simplify the complex structure of the hand so that you can more easily see in your mind what various poses will look like.

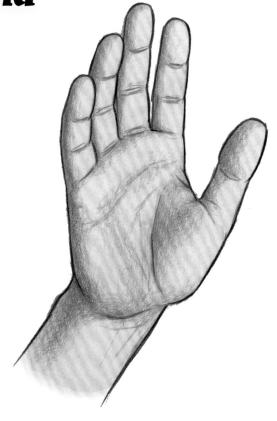

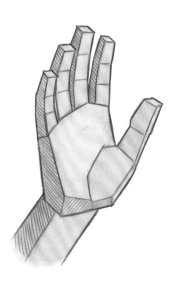

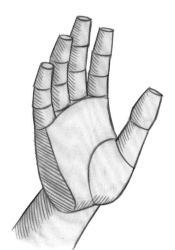

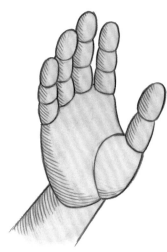

Angular
Many artists consider the hand as composed of boxlike structures. This is a great way of adding clarity to shapes that can seem amorphous and difficult to memorize. Next time you draw a hand, try imagining a boxy version like this and see if it helps you to see the hand in three dimensions.

Cylindrical
You may find it easier to envision the fingers and thumb as composed of cylinders. As long as you've got the proportions right, this simplified version may be all you need to fully imagine the hand in three dimensions.

Bubblelike
You can't get much simpler than this. Seeing the fingers and thumb as composed of bubblelike shapes can be a quick and easy way of envisioning how a hand will look in a particular pose.

The "Spider-Man" Hand

Here is an exercise that can help you improve your familiarity with the surface of the human hand. I call it the "Spider-Man" hand, since the finished drawing looks a little like the webbed surface of everyone's favorite web-slinging superhero.

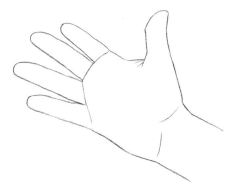

1 Draw the Contour

Looking at your own hand, do your best to draw its contour, just the outer edges. No need to worry if it isn't perfect. This is more about training your eyes than about trying to create a masterpiece.

2 Add the Length Lines

Training your eyes on one of the fingers, begin adding lines to the drawing that follow the length of the finger, from its tip to its base. Take care to make each line an accurate reflection of where such a line would fall on the hand if it were really there, making its way across the surface.

3 Add the Width Lines

Add lines across the width of that very same finger, intersecting the lines you made in step 2 at right angles. Again, you must study the surface of your hand carefully, to make sure the lines you're drawing are curved in just the right way to convey the surface of the skin at that particular point.

4 Continue to Completion

Extend this method across the entire drawing, until you've covered every tiny part of its surface. If you take your time and commit yourself to accuracy, this exercise will force you to study the hand as you never have before. In doing so, you will begin to understand the various surfaces of the hand and how they connect with one another. This knowledge will improve your accuracy any time you try to draw a hand in the future.

Hand on Hip

There aren't many poses more common than a hand resting on the hip. It's something people do every day, yet it can be devilishly hard to draw. Where does the thumb go? What about the fingers? This lesson provides good practice for anyone who has struggled to draw this ordinary, everyday (yet surprisingly challenging!) hand pose.

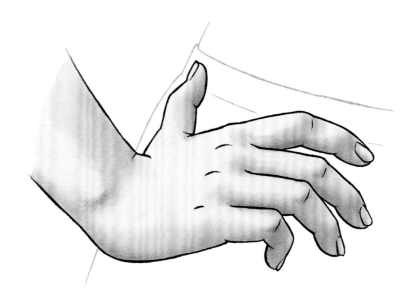

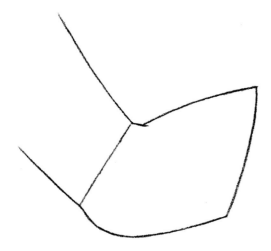

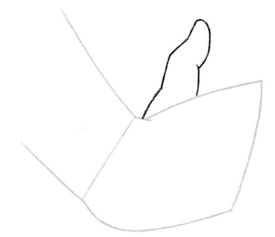

1 The Wrist and Palm

Begin by drawing the wrist and the palm. Note the angle that the wrist forms when it connects with the palm. It is not quite a ninety-degree angle, though it comes close in the area of the upper contour lines. There is a slight bulge where the lower wrist line joins the lower surface of the palm.

2 The Thumb

When drawing the thumb, pay attention to the sharp angle it must adopt as it conforms to the surface of the hip. The division between the two parts of the thumb is plainly visible here, as is the tip of the thumb curving back, away from the palm.

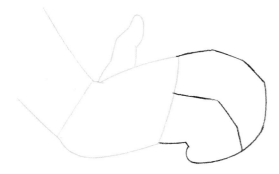

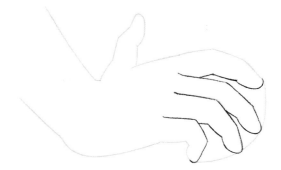

The Finger Guidelines

As usual, I find laying down a few guidelines can make the task of drawing fingers considerably less arduous. The upper line, which lays the groundwork for the index finger, is bent in two different places at very slight angles. The lower line is bent much more sharply; it will aid in drawing the pinky. I've added a third line across the middle of this shape to help in placing the ring finger.

The Fingers

Begin drawing the individual fingers. Go slowly with this step, it's a tricky one. This time I'd advise starting with the pinky, as it is fully visible, taking care to maintain the proper width of it in all three sections. As you proceed to drawing the ring, middle and index fingers, use the curved line you drew in step 3 to get the tip of each finger in just the right place.

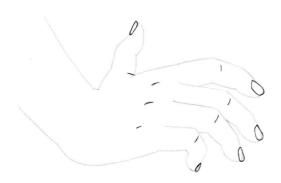

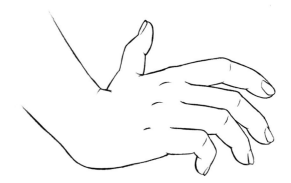

The Details

Happily, there are only a few details needed to finish the drawing. First add fingernails to the tips of each finger. Take care to shift the nails toward the top contour line of each finger, since each finger is slightly turned away from the viewer. Short dashes across the first knuckle of each finger can help to convey the structure in that area.

The Finished Drawing

Now it's time to erase any guidelines that remain visible from steps 1 and 3. And there you have it: the often-needed "hand on the hip" pose. Next time you need to draw characters with their hands posed this way, let this lesson be your guide.

A Clenched Fist

You won't get very far into drawing an action scene before you are confronted with the challenge of drawing a clenched fist. When all those fingers curl in on themselves, the entire shape of the human hand changes in a dramatic way, creating a hand pose unlike any other. Happily, it need not be a frustrating thing to draw. Follow this lesson for a foolproof step-by-step method.

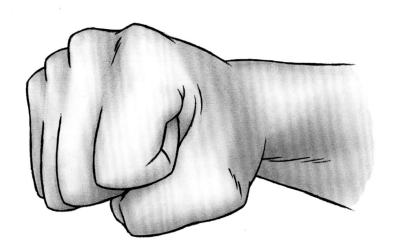

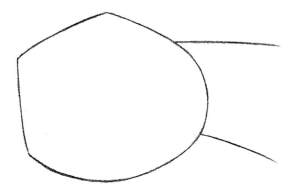

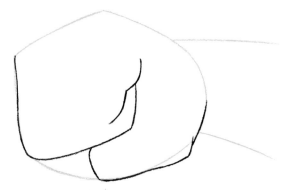

1 The Wrist and the Ball of the Fist

When drawing a fist, rather than try to draw a palm and then draw the fingers, it's easier to simply draw the entire "ball" of the fist at once. Begin by drawing a shape that is an oval on one side and angular on the other: two straight lines that will help you place the individual fingers in subsequent steps. Then add two horizontal lines on the right-hand side to serve as the contours of the wrist.

2 The Finger and Thumb Guidelines

Before drawing individual fingers, let's get some basic guidelines in place. Begin by carving the ball of the fist into two sections: a boxy section on top that lays the groundwork for the fingers and a long, rectangular section below that delineates the thumb. Pay attention to the proportions between these two sections. The area devoted to the fingers is much larger than that devoted to the thumb.

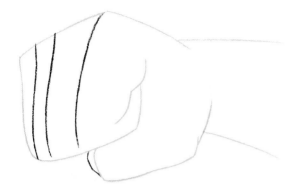

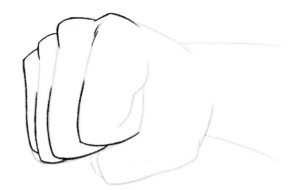

The Finger Guidelines

Now add three vertical lines to the area of the fingers, so as to lay the groundwork for final line work in step 4. Since the fist is slightly turned away from us, these lines are more tightly packed on the left than on the right, conveying the fact that the pinky is farther away than the index finger. Then you can add a small curved line to the thumb. This is the tip of the thumb, bent back to hold the fingers in place.

The Fingers

Use the guidelines from the previous steps to add final line work to the area of the fingers. Draw curved lines in the area of each knuckle, allowing the lines to cross one in front of the other, so as to convey a stacked arrangement of the knuckles. Similarly, the sharply angled lines at the bottom of the fingers must cross one in front of the other. Note that the pinky, as you would expect, is shorter in length than the other fingers.

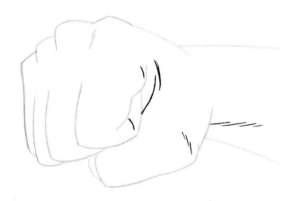

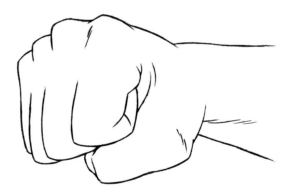

The Details

Now it's just a simple matter of adding wrinkles to the area where the index finger curls in against the flesh of the palm. If you clench your own right hand into a fist, you can see how this occurs in real life. Finally, add a few lines to the base of the wrist to convey a little more structure in that area.

The Finished Drawing

If there are any guidelines still visible from steps 1 and 2, carefully erase them now. While drawing the human fist is certainly no cake walk, it is something worth practicing. Next time you need to draw your favorite hero joining the fight, I hope this lesson can help you take that drawing to the next level.

Common Hand Drawing Mistakes

It's not enough to simply show a bunch of nicely drawn hands and say, "Do it this way." Sometimes you need to see a badly drawn hand and have its errors pointed out to you so that you understand what to avoid. Here are two side-by-side comparisons, showing just what separates a poorly drawn hand from a well-drawn one.

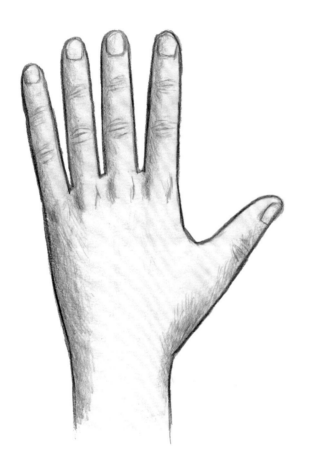

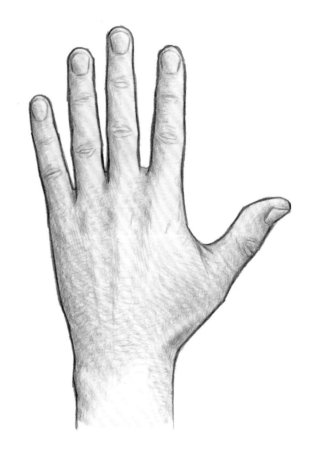

Things I Got Wrong

In this drawing all the fingers are pretty much the same length. The knuckles are too visible and placed too closely to the base of the fingers. The thumb's shape is too simple—it lacks the subtle angles seen in an actual thumb. This is the sort of drawing one might do when trying to draw a hand entirely from memory.

Things I Got Right

Here's what you get when you allow yourself to look at an actual hand while drawing, studying it carefully, instead of relying only on your memory of what a hand looks like. The length of the fingers varies, one from the other, with the pinky being noticeably shorter than the others. The contour of the thumb is much more complex, conveying its two-part structure to the viewer. There are wrinkles at the point where the thumb joins the palm. All of these little details contribute to a hand that looks much more like the real thing.

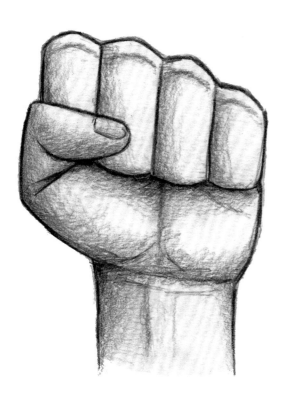

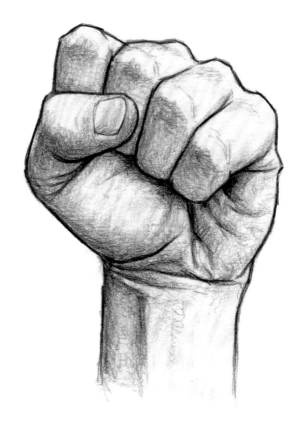

Things I Got Wrong

Let's look at a drawing of a fist. This one has all the hallmarks of a drawing done completely from memory, an educated guess at what a fist looks like, rather than a drawing based on observation. The fingers are lined up too neatly, all of them parallel with the lines of the wrist. The thumb is bent at angles far sharper than is possible with an actual human thumb. The thumbnail looks as if it were tattooed across the surface of the thumb, rather than embedded into it.

Things I Got Right

An actual fist is far more complex. The fingers are lined up with one another, but they form a unique arrangement of cascading angles. Each finger pointing in a slightly different direction from the one that precedes it. The thumb must tilt substantially to one side to maintain its grip on the fingers, allowing us to see the thumbnail in a three-quarter view. This is the kind of drawing you get when you use reference, rather than depending solely on your own flawed memory of the thing you're trying to draw.

Picking Up a Small Object

Now that we've covered some of the essential everyday hand poses, it's time to move on to something a little more unusual. When people need to pick up a tiny object, they often rely on just their index finger and thumb to do the job. In doing this, the other fingers naturally curve back and stay out of the way. The result is an interesting and delicate hand pose well worth learning.

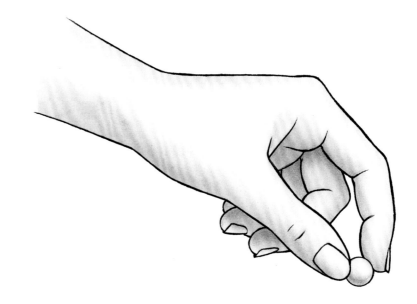

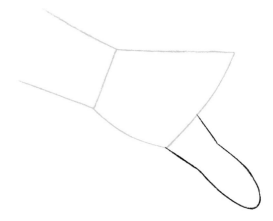

1 The Wrist and Palm
When the human palm is seen from the side, it often appears slightly trapezoidal in shape, with its smaller side at the wrist and its larger side near the base of the fingers. Once you've drawn such a shape, add two lines to delineate the upper and lower contours of the wrist.

2 The Thumb
Now add the basic shape of the thumb, having it tilt at a slightly lower angle than that of the wrist. As always, you should take care to reveal the thumb's two-part structure in the way you render the contour. It is wide at the base, narrow near the knuckle and wide again as it heads toward the tip.

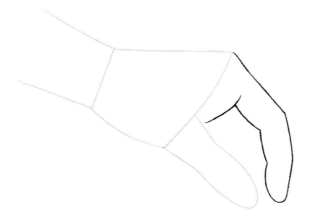

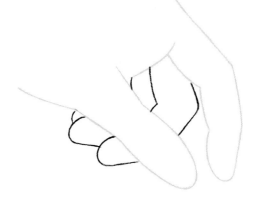

The Index Finger

Once the thumb is in place, you can add the index finger. Note that the three phalanges that compose the index finger are of a similar length on the underside of the finger, but this is not the case with the upper contour line. It is a long line from the base of the finger to the first knuckle, followed by a shorter line leading to the next knuckle, followed by an even shorter one leading to the tip.

The Remaining Fingers

Now it's time to draw the other three fingers. Since they are partially obscured, you must take care to place their contour lines so that they appear to connect in the space behind the thumb. Happily, the pinky is so thoroughly hidden from view, all that is needed to convey its presence is a small curved line near the base of the thumb.

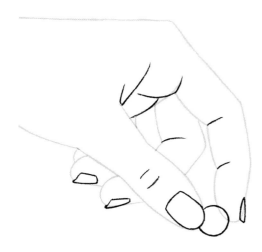

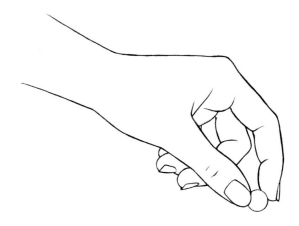

The Details

As you near the completion of the drawing, add lines to the lower contours of the fingers to clarify the structure of the individual phalanges. When drawing the thumbnail, take care to accurately render its size in proportion to the thumb as a whole. Finally, add wrinkles to the area where the thumb joins the palm. When the fingers curve inward, the pads of flesh in this area press up against one another and get more wrinkly than usual.

The Finished Drawing

Erase any guidelines from step 1 that remain visible. Pat yourself on the back. You've nearly completed all the lessons in this first chapter. With every hand pose you draw, you will become a little more familiar with the various parts of the hand and how they all fit together.

Hand Gripping a Pole

Among the many tricky hand poses an artist may be called to draw, a hand gripping onto something is uniquely challenging. So often the fingers in the drawing don't look like they are actually touching the thing they're supposed to be wrapped around. With this lesson, I'll show you a simple method of drawing a hand gripping a pole, giving you all the guidance you need to draw the fingers in just the right place.

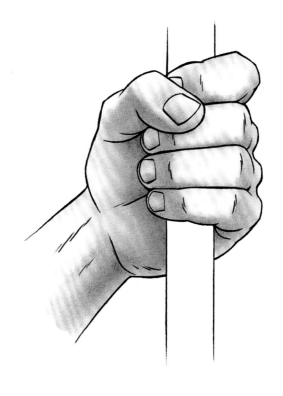

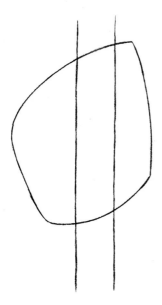

1 The Pole and the Ball of the Fist

Let's begin by drawing the pole itself: two vertical lines, side by side (feel free to use a ruler if you like; artists use them all the time). Draw a guideline for the general location of the palm. Note the points at which this palm shape crosses the lines of the pole. Here it is shifted off to the left-hand side and is tilted down at an angle.

2 The Wrist and Basic Finger Guideline

Now add two diagonal lines on the left to serve as the contours of the wrist. Take care to have these lines connect with the palm shape at the two points you see here. Then draw an L-shaped line as a guideline for the finger placement in steps 3 and 4. Again, the position of this line is important. Pay attention to where it touches the line of the palm and where it crosses the lines of the pole.

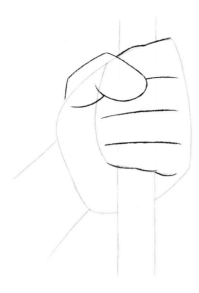
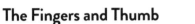
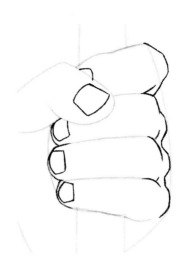

The Fingers and Thumb

Draw the thumb first, taking care to have its tip angle down into the space between the two lines of the pole. Use the guidelines from step 2 to help you divide the area of the fingers with horizontal lines, creating four subsections of roughly equal size. (The section devoted to the pinky, naturally, is a bit smaller than the others.)

The Fingers and Fingernails

Now draw the contour of the knuckles. Note that the index finger, due to the angle of the pole, is unable to wrap around the pole as tightly as the other fingers. This causes its contour line to be shifted farther out than that of the other knuckles. When drawing the fingernails, pay attention to the placement of the thumbnail, which, due to the angle of the thumb, is shifted slightly to one side.

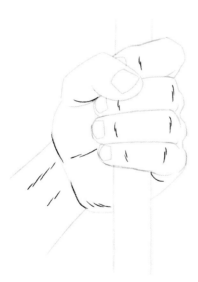
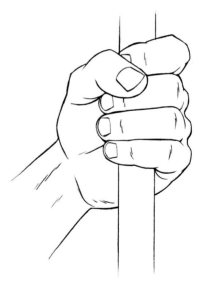

The Details

You've done the hard work of line placement. Now it's a comparatively simple matter of adding details. Drawing a few short vertical lines across the fingers helps to show how each finger is bent to wrap around the pole. An added line or two at the base of the palm can help convey the structure in that area.

The Finished Drawing

Erase any guidelines that remain visible from steps 1 and 2, and you're done! If you found this lesson difficult, never fear. There's a lesson later in the book ("Holding a Sword" on page 118) that will provide you with further practice on this pose.

Fingernails

Drawing hands is hard enough all on its own. But then there's the extra-tricky matter of drawing the fingernails. Believe me, I've struggled with drawing them over the years; we all do. Here are some tips to help you draw nails more confidently.

1 The Guidelines
To make sure you draw the fingernail in the right place, it can be helpful to draw a couple guidelines: one near the tip of the finger and the other farther up where the cuticle will be. A third line up the middle of the finger can help with centering the fingernail.

2 The Fingernail
Use these lines to help you draw the nail in the right place. Of course nails come in all shapes and sizes, but the shape I've used here—a bit like an old arched window—is a reliable one that can work for both male and female hands.

3 The Finished Drawing
Next time you have to add nails to a hand you've drawn, give this method a try. A few simple guidelines at the outset can save you a lot of frustration later on.

Drawing Nails from the Side

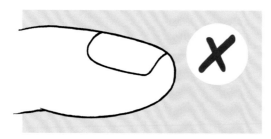
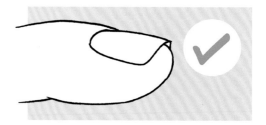

Incorrect
When drawing a fingernail from the side, it can be tempting to simply draw the shape of the fingertip, and then add a line or two for the nail. This, however, is not the way real nails look when viewed from the side.

Correct
An actual fingernail is embedded into the fingertip in a way that alters the contour line in that whole area. Here you can see how the nail dips down a bit as it emerges from beneath the skin of the cuticle. If you add this extra level of detail, you will be rewarded with a drawing in which the nails look much more realistic.

The Thumb

Every lesson in this book will give you some practice in drawing the human thumb. Even so, it is a subject worthy of closer attention, as even a seasoned professional can struggle to get the shape and size correct. Here are some tips to help you gain a deeper understanding of the thumb and how it relates to both the fingers and the palm of the hand.

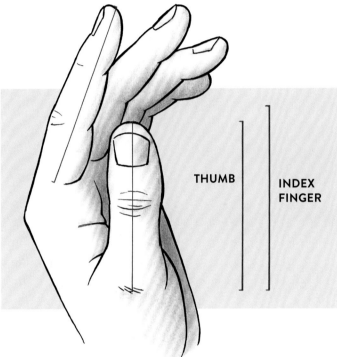

Thumb Length

One fundamental aspect of the thumb that can be challenging to memorize is its length in relation to the fingers. When we measure the underside of the index finger from the fingertip to the spot where it meets the palm, we find that this distance is a touch longer than the thumb. If you keep this in mind whenever you're drawing hands, you can make sure to always have the thumb just a bit shorter than the index finger, and in so doing maintain proper proportions in your drawing.

The Flexibility of the Thumb

They don't call it the "opposable thumb" for nothin'! The thumb is highly flexible, and it can pivot quite a distance across so as to touch the base of the pinky. When the thumb moves in this way, it brings a substantial part of the palm with it. In this sense an artist cannot treat the thumb and the palm as two separate sections of the hand. When one moves, the other moves with it, causing the entire contour of the palm to change drastically from one pose to another.

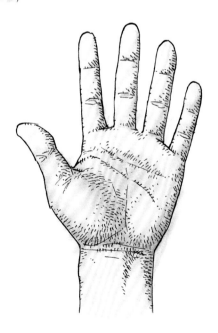
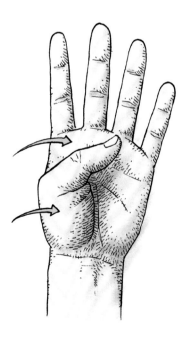

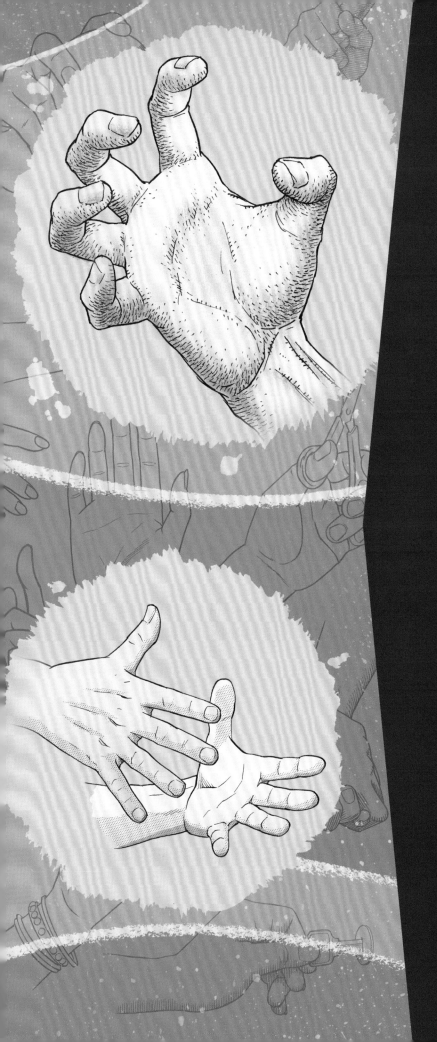

PART 2

Hand Gestures

Among the many everyday tasks that the human hand performs, one of the most interesting is that of communication. Hand gestures allow us to add extra layers of meaning in conversation, subtle signals that are difficult to express with words alone. This chapter will teach you how to draw a wide variety of hand gestures and will help you to understand the meanings behind them.

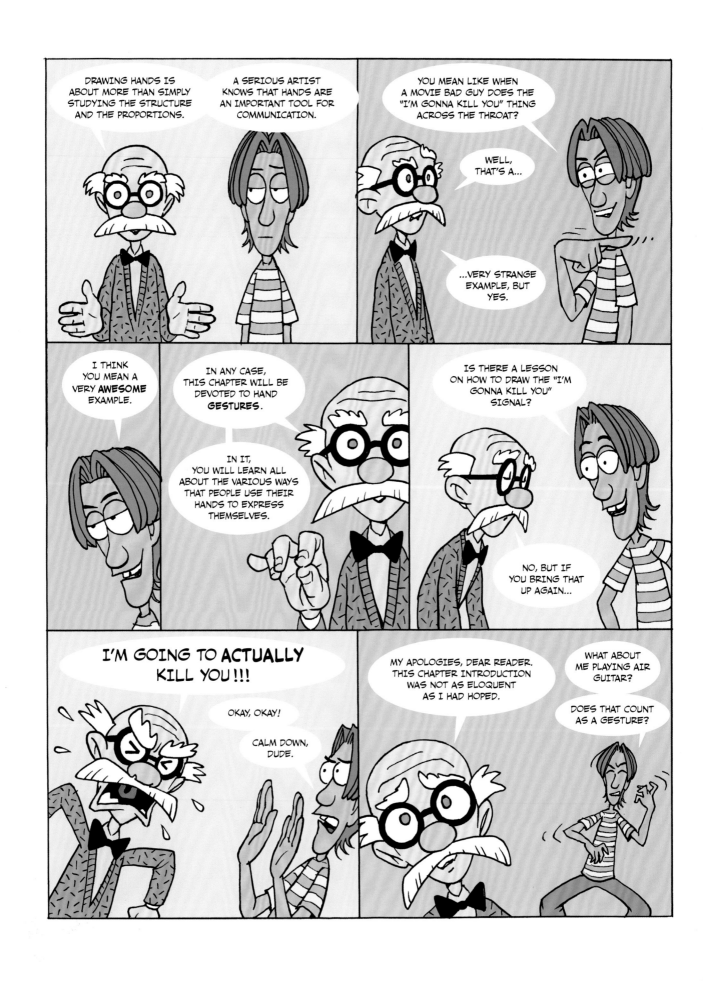

The Importance of Hand Gestures

Drawing hands is important for almost any kind of artist, but for comic book artists, it is an absolutely essential skill. And when hands are drawn in comics, they are very often being used to accentuate dialogue scenes by way of hand gestures. Compare these two versions of the same comic book panel—one with hand gestures and one without—to see just how important hand gestures can be.

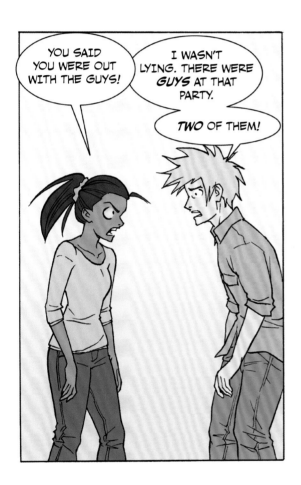

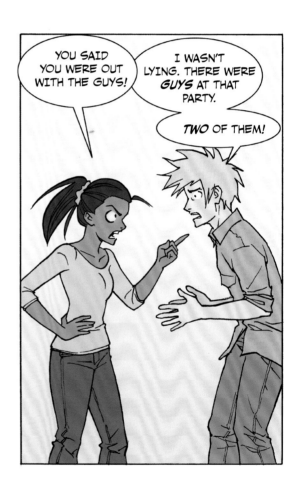

No Hand Gestures

It's a simple enough scene: the two characters are having a bit of a spat. Their facial expressions show that they are arguing with each other, but the level of confrontation seems weak. Something is missing.

Hand Gestures Added

Here we see the exact same scene but with hand gestures added. See what a difference they make? Her pointed finger underscores the fact that she is accusing him, but the hand on her hip also adds something to the scene: she seems to have more strength and self-confidence than she did before. As for the young man, his hand gestures demonstrate that he is eager to explain himself and to persuade her of his innocence.

A Conversational Gesture

For our first lesson on drawing hand gestures, let's start with one of the most common gestures seen in conversation. This relaxed open-palmed gesture is used all over the world (unconsciously, for the most part) to add a gentle touch of emphasis to whatever the speaker is saying. Something about it seems to say, "You know what I mean? You're with me, right?" It's an easy gesture to make. Drawing it, however, is a bit more challenging!

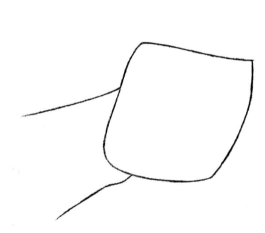

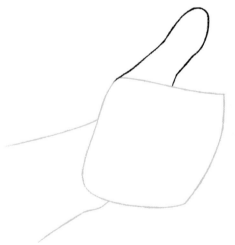

The Palm and Wrist

Let's begin by drawing the palm: a square-ish shape that is rounded near the base of the palm. Now add lines for the contours of the wrist. When drawing these two lines, pay attention to the width of the wrist in comparison to the width of the palm. The wrist is narrower by a considerable margin.

The Thumb

By now you've had some experience with drawing the shape of the thumb, so this shouldn't be too much trouble. Note the angle at which the thumb extends from the palm. It is not quite parallel with the lines of the wrist. It points upward, away from the palm.

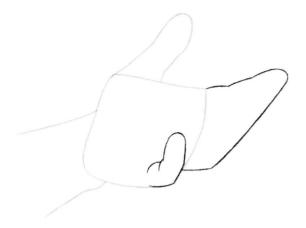

The Finger Guidelines

As usual, let's place some basic guidelines in preparation for drawing the fingers. In this pose, the pinky is going to be visually separate from the other fingers, so you need to draw its contour in isolation, bending upward in the lower right-hand corner of the palm. Now you can add a large triangular shape off to the right that lays the groundwork for drawing the remaining fingers.

The Fingers

Begin by drawing the ring finger, as it the closest to us of the three and unobstructed by the other fingers. Note that this finger is bending upward in a way that allows its fingernail to be partially visible. Next draw the middle finger. It is bending more gently than the ring finger, its angles less pronounced. Finally add the index finger, the one finger that is hardly bending at all.

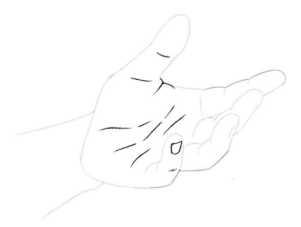

The Details

All that remains now is to add a few details, mostly in the area of the palm. Draw a few diagonal lines in the center of the palm to show the wrinkling of the flesh in that area. One or two lines across the thumb can help to convey its structure to the viewer. And don't forget the pinky fingernail. Since the tip of the pinky is turning away from us, the fingernail needs to shift over a little to the right-hand side.

The Finished Drawing

Erase any guidelines that remain visible from steps 1 and 3, and you're done. Next time you have to draw a character who is in the middle of a conversation, try making this hand gesture a part of the drawing. It will add an extra level of naturalism and expressiveness to the scene.

Another Conversational Gesture

There are so many gestures people make in conversation, and we will cover a bunch of them on the pages that follow. But this one is particularly common as it is a gesture that people employ when they are trying to make a point. A downward-facing palm with fingers stretching forward forms a gesture that is all about persuading others to the speaker's point of view. In this lesson we'll learn to draw this hand gesture, step by step.

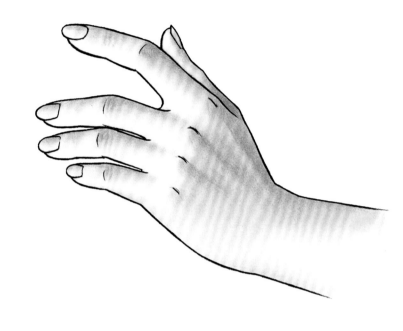

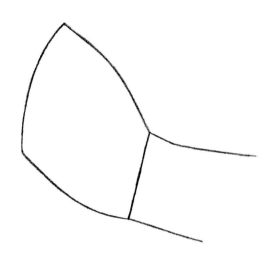

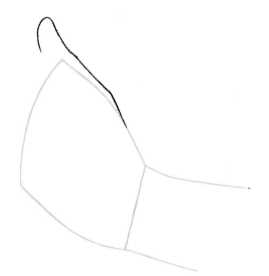

1 The Back of the Hand and Wrist

Begin by drawing the back of the hand. When seen from this angle, it has a slightly conelike look: narrow at the wrist and wider near the area of the knuckles. Once you've drawn the back of the hand, add two contour lines for the wrist.

2 The Thumb

In this pose the thumb is partially obscured, so you are saved the trouble of drawing it in its entirety. Still, you must pay attention when you draw its contours. There are two subtle angles in the line where the knuckles are located. The tip of the thumb, as it tends to do, is curving back just a little, pointing away from the rest of the hand.

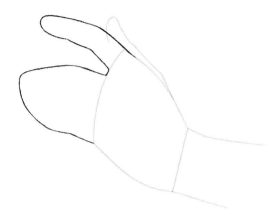

The Finger Guidelines

In the previous lesson the pinky was slightly isolated from the rest of the fingers. This time it's the index finger that is going its own way. When drawing these guidelines, pay attention to the space between the index finger and the shape that represents the other three fingers. If you can replicate that blank space in your drawing, you have a better chance of getting all the lines in the right place.

The Fingers

Now it's time to draw the remaining fingers. Again, the tiny slivers of blank space *between* each finger can help you as you work to get the shapes right. Don't just draw the fingers, draw the spaces between the fingers.

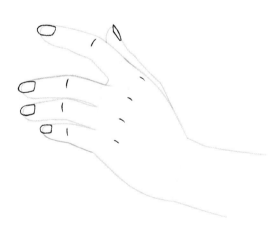

The Details

In many ways the drawing is already complete. But you can take it to a higher level by adding fingernails to the tips of each finger. I chose to draw relatively long fingernails, but feel free to draw them at any length you prefer. A single short dash across the first knuckle of each finger can go a long way toward conveying the structure of each finger.

The Finished Drawing

If any guidelines remain visible from steps 1 and 3, erase them now so only the final line work remains. This hand gesture, as well as the one taught in the previous lesson, can be added to almost any dialogue scene you draw. When you see people talking in real life, pay attention to the conversational gestures they make. It's a great way to learn new hand gestures that you can work into your drawings.

Common Conversational Gestures

It would be impossible to make a truly comprehensive chart of all conversational hand gestures. There are simply too many of them. Here you will find many of the most common ones, along with a brief description of what sorts of messages they communicate. Return to these pages anytime you need to enhance a conversational scene with a bit of "hand language."

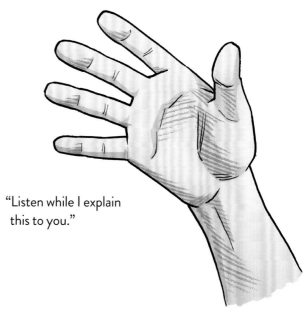

"Listen while I explain this to you."

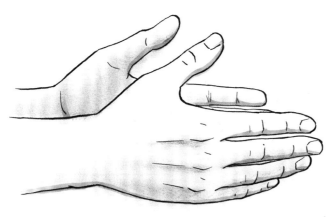

"I really need you to understand me and be on my side."

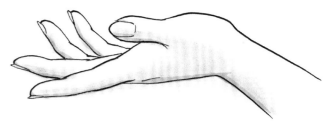

"Know what I mean? Don't you feel the same?"

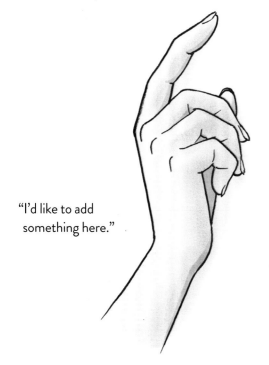

"I'd like to add something here."

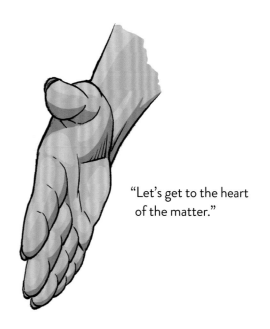

"Let's get to the heart of the matter."

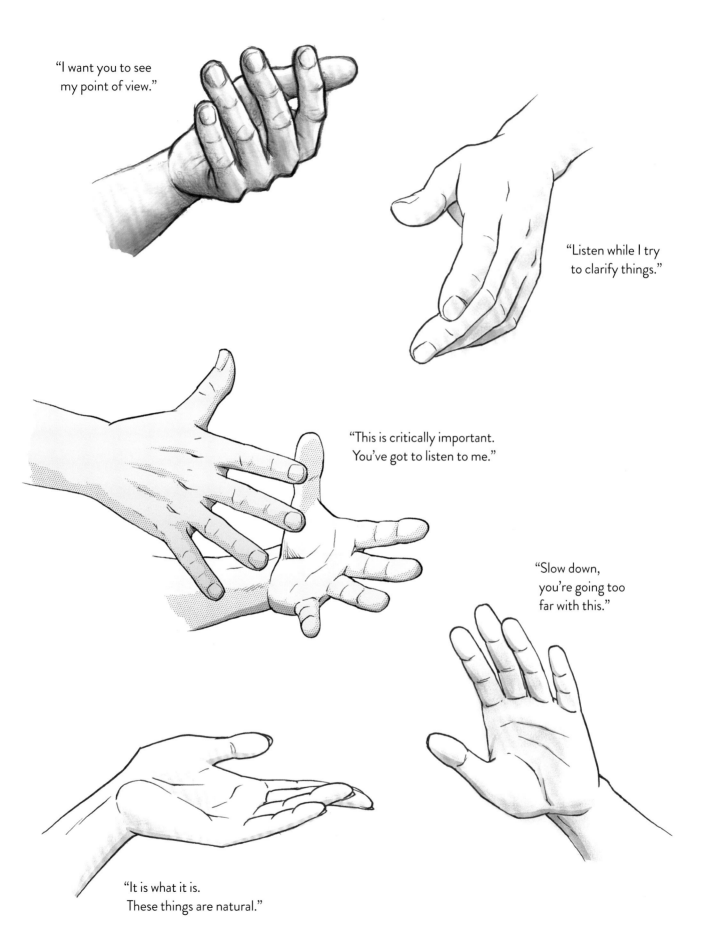

"I want you to see my point of view."

"Listen while I try to clarify things."

"This is critically important. You've got to listen to me."

"Slow down, you're going too far with this."

"It is what it is. These things are natural."

The "Okay" Sign

Now that we've covered conversational gestures, it's time to get into hand poses that are designed to send one particular message. Among these hand signals, perhaps the most universal is the "okay" sign, in which the thumb and index finger are joined to form an O shape. People use this gesture every day, all over the world, to send the message that everything is all right. But can you draw it?

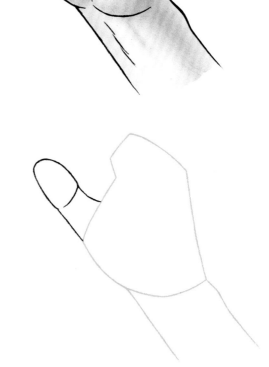

1 The Palm and Wrist

Begin by drawing the contours of the palm, a shape that is quite angular at the top but rounded at the bottom. Note that this shape is taller than it is wide, and that is much wider near the bottom than it is near the top. Now add the lines of the wrist, angling them so that they are both diagonal and parallel to each other.

2 The Thumb

This hand pose allows a nice clear view of the thumb and its two-part structure. The base of the thumb is wide where it attaches to the palm and tapers a bit as it extends outward, a bit like the trunk of a tree. The tip of the thumb is more oval-shaped, something like a gumdrop. You should always try to make these two separate sections plainly visible anytime you draw a thumb.

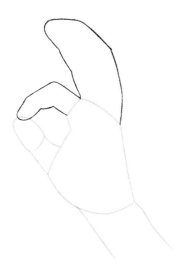

The Finger Guidelines

Draw the index finger. When a person makes the okay sign, the three-part structure of the index finger is very plain indeed: you can see each angle as the finger bends down to touch the tip of the thumb. Once you've got the index finger in place, draw a guideline shape for the remaining fingers. This shape looks a little like a bird's wing, rising up and away from the palm.

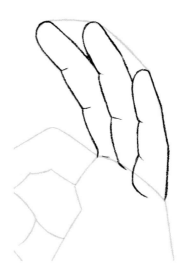

The Fingers

Using this winglike shape as your guide, draw the remaining fingers, beginning with the pinky. Note that each finger curves to a slightly different degree. The pinky is close to vertical, while the ring finger bends a little to the left, and the middle finger bends even more. If you like, you can add little lines at the base of each phalange, further clarifying the structure of each finger.

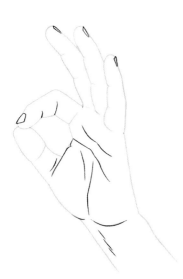

The Details

It's time to finish off the drawing with a few details, primarily in the area of the palm. One or two lines across the upper part of the palm are needed to show the creases of the flesh in that area. Add a couple of vertical lines to show the structural divide between the right and left half of the palm, and also draw some wrinkles at the base of the thumb, where it joins the palm of the hand.

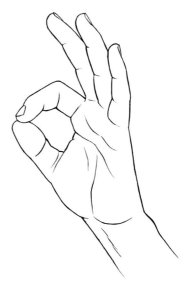

The Finished Drawing

Not much erasing is needed in this lesson, but if you see any unwanted guidelines remaining from steps 1 and 3, now's the time to get rid of them. As you can see, drawing an "okay" sign properly is more challenging than you might first imagine. But what about drawing a "thumbs-up" sign? Well, there's only one way to find out!

The "Thumbs-Up" Sign

If any hand signal could give the "okay" sign a run for its money in terms of popularity, it might be the "thumbs-up" sign. In the age of the internet, we see little icons representing this gesture many times a day. But drawing it realistically requires a bit more attention to detail. This lesson will take you through the process, step by step.

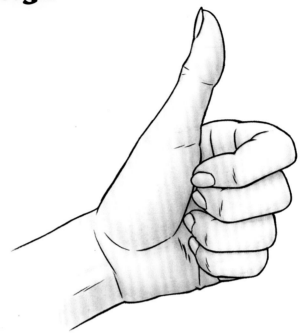

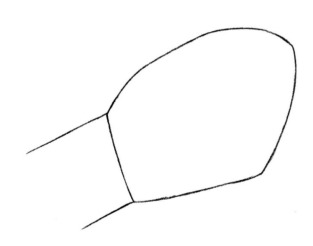

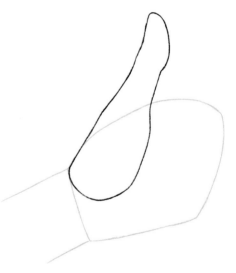

1 The Palm and Wrist

This pose is similar to that of a clenched fist, in that the fingers and the palm come together to create a single, ball-like shape. Note that the right-hand side of this shape looks as if it has had a section lopped off. This shape will help with lining up the fingers in subsequent steps. When drawing the contour lines of the wrist, pay attention to the proportions between the wrist area and that of the palm.

2 The Thumb

As you would expect, the "thumbs-up" hand gesture makes the thumb the star of the show. In contrast to previous lessons, it is helpful here to draw the thumb as a single large shape, interconnected with the flesh of the palm. The pose is such that the two areas read as a single form, something that looks a bit like a chicken drumstick. Since we are seeing the thumb from the side, be sure to show how the tip of the thumb tilts back a bit, away from the palm.

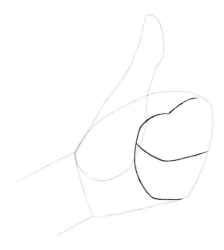

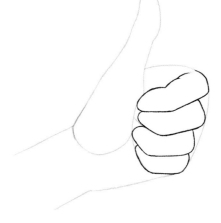

The Finger Guidelines

To get the fingers in the right place, let's start with some back guidelines. Imagine that you're drawing a mitten or a boxing glove. Then draw a curved line across the middle to start the process of dividing this area into four individual fingers.

The Fingers

Begin drawing the fingers, one at a time, starting with the index finger. Note that as you draw each finger you are also including the contour of each knuckle on the right-hand side, changing the contour of the mitten shape into something that looks more like a flight of steps.

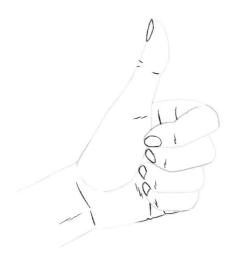

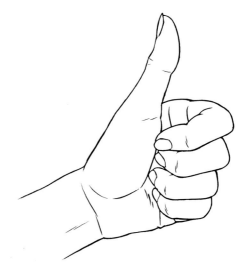

The Details

When seen from a distance, a thumbs-up doesn't have much in the way of details. But you'll at least want to add fingernails and a thumbnail. Since the fingers are turning away from us in a three-quarter point of view, each nail has to be shifted down a bit, so as to fit properly onto the fingers. For extra realism, try adding a couple wrinkles to the underside of the index finger and to the base of the palm.

The Finished Drawing

There may be a few guidelines still visible from steps 1 through 3, in which case you'll want to carefully erase them now, leaving just the finished line work. Voilà! A thumbs-up that puts all those little Facebook icons to shame.

Hand-on-Chin Poses

Another common hand gesture that we see every day is that of people resting their chins upon their hands. While you might think they all send more or less the same signal—the person is tired or bored—this is not the case. Here are four common hand-on-chin poses, with brief descriptions of the messages they communicate.

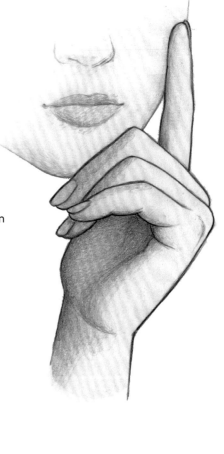

"I'm listening. I'm considering the merits of what you're saying."

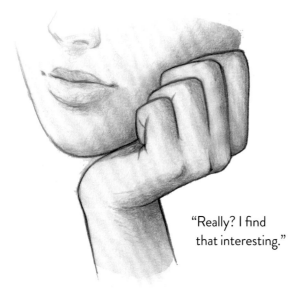

"Really? I find that interesting."

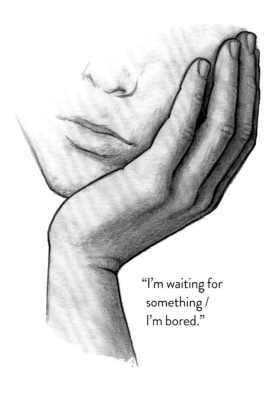

"I'm waiting for something / I'm bored."

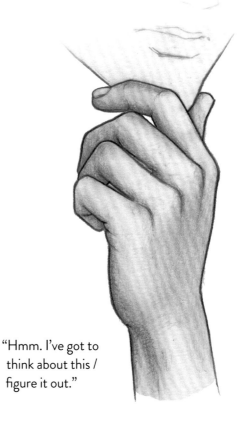

"Hmm. I've got to think about this / figure it out."

Struggling Hands

When a person is struggling or in terrible pain, their hands can take on highly dramatic poses, especially in a comic book fight scene. Here are two such poses. The one on the left shows a hand at the very height of a struggle: grasping at the air, tensed in agony. The one on the right seems closer to losing the battle. Though it is still clawing at the air, we sense that this person will soon lose consciousness.

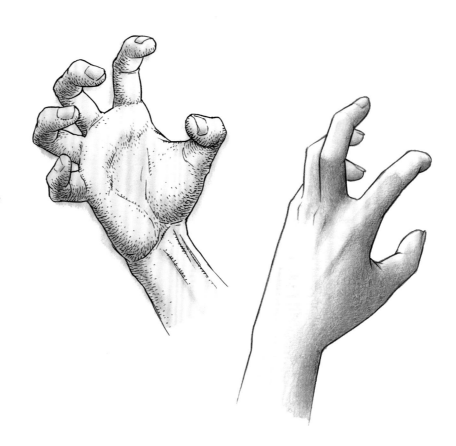

Lifeless Hands

When a person loses consciousness, their hands go into a distinctive lifeless pose, one that suggests the muscles have relaxed entirely. Here is one such pose, presented from two points of view. Note that the fingers do not lay flat but instead curl in a little toward the palm of the hand. If you ever need to draw such hands, consult this page for guidance.

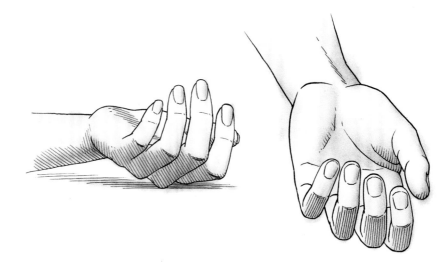

Pointing

Pointing at something is probably among the first hand gestures we learn to make. Most of us likely began pointing at things as babies. And while it is often a simple utilitarian signal—a way of guiding other's eyes toward something you want them to look at—it can also be a dramatic confrontational gesture. One that a person wields in the heat of an argument, to underscore an accusation.

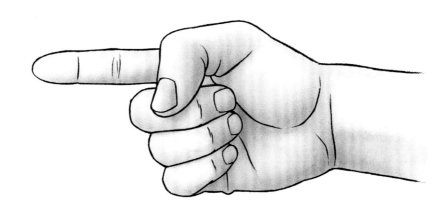

1 The Palm, the Thumb and Wrist
Let's begin with a preparatory shape that brings together both the palm and the tip of the thumb. To me, this shape resembles the head of a dog, with the thumb looking a bit like the dog's floppy ear. Then add two horizontal lines to the right-hand side of this shape, to serve as the contour lines of the wrist.

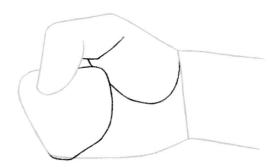

2 The Finger Guidelines and Base of the Thumb
Add a curving line in the center of the palm that will help lay the groundwork for drawing the fingers in the next step. Once this line is in place, you can draw the bulbous section of the palm that supports the thumb. Pay attention to the proportions of the thumb in comparison to this bulbous section of the palm. The latter is almost as big as the two parts of the thumb put together.

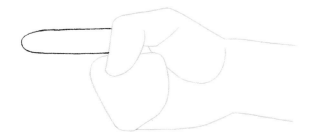

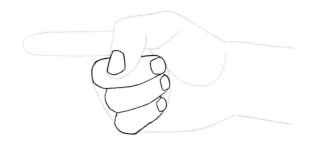

The Index Finger

Well, it wouldn't be a pointing pose without the pointer finger, now would it? When drawing the index finger, be careful about both its length and width. It is noticeably narrower from side to side compared to the tip of the thumb.

The Remaining Fingers

It's time to draw the other three fingers. Begin with the middle finger, which is held in place by the thumb. It is close to horizontal, with just a touch of a diagonal tilt. The ring finger is more diagonal in orientation, while the pinky is the most diagonal of them all. Once these fingers are drawn, add fingernails to them as well as to the tip of the thumb.

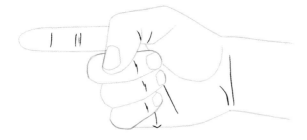

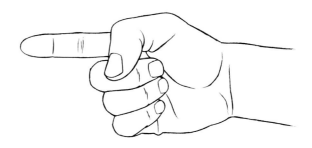

The Details

You're nearly done. Add a few wrinkles in the area of the palm and to the part of the thumb where it bends in on itself. Adding three short lines across each one of the fingers from step 4 can help show that those fingers are bent in toward the center of the palm. Finally, a couple vertical lines across the index finger will show the three phalanges that is it divided into.

The Finished Drawing

If any guidelines remain visible from steps 1 and 2, now is a good time to erase them. Next time you need to draw someone pointing at something (or, indeed, pointing angrily at the person they're arguing with!), turn to this lesson for a bit of guidance.

The Peace Sign

The V-shaped peace sign has been around for many years, and has meant different things to different people. These days it is more popular than ever because of the Japanese habit of making the peace sign (palm facing outward) while posing for photographs, a practice that has swept the globe. I can think of no better step-by-step lesson for ending our chapter about hand gestures. Peace!

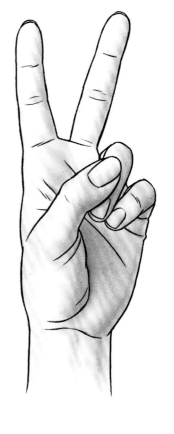

1 The Palm and Wrist
Start with drawing the basic shape of the palm. The shape is much less wide than it would normally be, due to the thumb pivoting over to the right in order to hold the pinky and ring finger in place. When drawing this shape, take care to replicate the angles of the upper contour, as each of the four fingers will be built upon that line.

2 The Thumb
This is another pose that allows a nice, clear view of the thumb. As always, you should take care to render the thumb as having two distinct parts: a "tree trunk" base and a tip that is more oval-shaped. Take care to get the angle of the thumb correct. It needs to lean decisively to the right in order to reach the fingers it's holding in place.

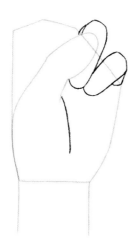

The Bent Fingers

Now that you've got the thumb in place, you can draw the ring finger and the pinky, both of which are bent down out of the way. In this version of the pose, the thumb overlaps only the ring finger, leaving the pinky unobstructed. Note the angles of the two fingers when you draw them. Then add a curving line to the base of the thumb to show how the palm is folding in on itself.

The V Fingers and Fingernails

Now we can finally get to the star of the show: the peace sign formed by the index finger and the middle finger. Note that the index finger is more or less vertical, while the middle finger has a strong diagonal tilt to it. When drawing the thumbnail, shift it a bit toward the left contour line of the thumb, so as to show that it is slightly turned away from us.

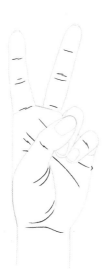

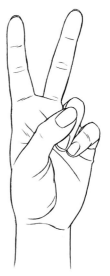

The Details

Since the peace sign requires the thumb to bend inward, a number of wrinkles are created across the surface of the palm. The thumb crosses in front of the diagonal wrinkles in the center of the palm, so you need to make sure they line up with each other on either side. Note that the wrinkles on the thumb's side of the palm curve quite a bit, revealing the rounded surface of that area.

The Finished Drawing

There may be some unwanted guidelines still visible from step 1, so make sure to erase them along with any other lines that aren't to your liking. And there you are! A proper drawing of a peace sign. Even when drawing this pose in a cartoony way, it is helpful to remember everything you learned in this lesson about where the fingers go, and the various directions they head in.

The Wrist

I made a decision not to go too far into the complexities of human anatomy with this book, believing that an excess of such material can be overwhelming for many beginning artists. But when it comes to drawing hands, there are some aspects of the internal anatomy that artists should be aware of. This is very much the case when drawing the wrist.

The Ulnar Styloid Process

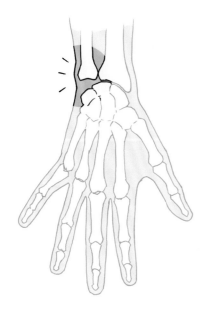 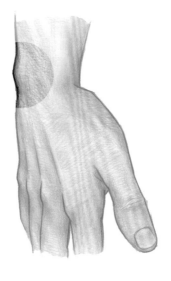 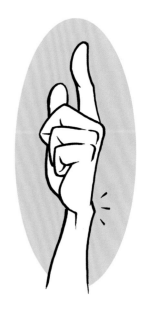

In this illustration of the bones of the hand, I have placed a special focus on one particular section of bone that comes quite near to the surface of the skin. It is called the *ulnar styloid process*. If you examine your own wrist, looking at its upper surface on the pinky finger side of the hand, you may be able to observe the ulnar styloid process and even feel the hardness of this bone right there beneath your skin.

Depending on what angle you're viewing the wrist from, the ulnar styloid process can alter the contour of the wrist to a noticeable degree. If you've memorized its location, you'll know when to alter your drawing to include the little bump that it makes.

Cartoonists will sometimes include the ulnar styloid process in their drawings, even in drawing styles that are otherwise highly exaggerated. The key is to remember its location in relation to the pinky. You're not going to see it in every drawing you make. It's only visible when the wrist is viewed from just the right angle.

The Knuckles

Once you've improved your ability to draw the basic shape of the hand, it's time to move on to the detail work that can take your drawing to the next level. Among these details, one of the most important things to focus on is the knuckles.

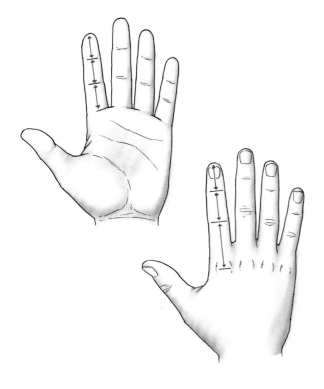

The Location of the Knuckles

Even a casual observer of the human hand can see that the fingers are divided into three different parts, allowing them a great deal of flexibility. What you may not have noticed is that these division patterns are markedly different depending on whether you're looking at the upper surface of the fingers or the lower surface.

In the picture on the left you see the underside of the fingers. The size of the three finger phalanges is pretty much identical. In the picture on the right you see the outer surface of the fingers. On this side of the hand, we find that the knuckles are not as evenly placed as you might expect. Those near the tips of the fingers are tightly packed. The lower knuckles on the back of the hand are quite some distance from the middle knuckle, and so on. So when you draw the knuckles, you have to remember this way of spacing them to make your drawing accurate.

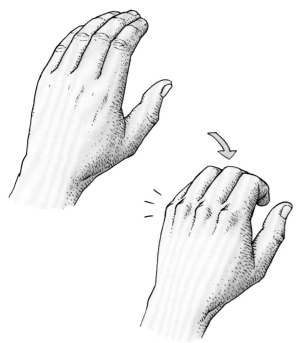

Now You See Them, Now You Don't

Another thing to keep in mind is that the knuckles are not always plainly visible. If you lay your hand flat on a table like the left image, you may observe that the knuckles along the back of the hand recede into the flesh and are largely hidden from view.

When you bend your fingers forward as in the right image, the knuckles emerge and become easier to see. This is because what we call *knuckles* are in fact bones beneath the skin's surface, and the more you bend your fingers, the more these bones rise up and become visible through the flesh. Clench your fist tightly, and the knuckles become as clear as they can be.

As an artist, you need to keep this in mind. There is no need to draw the knuckles when the hand you're drawing is stretched out flat with the fingers extended. But when the fingers bend, and especially when the hand becomes a fist, it's time to get those knuckles into your drawing.

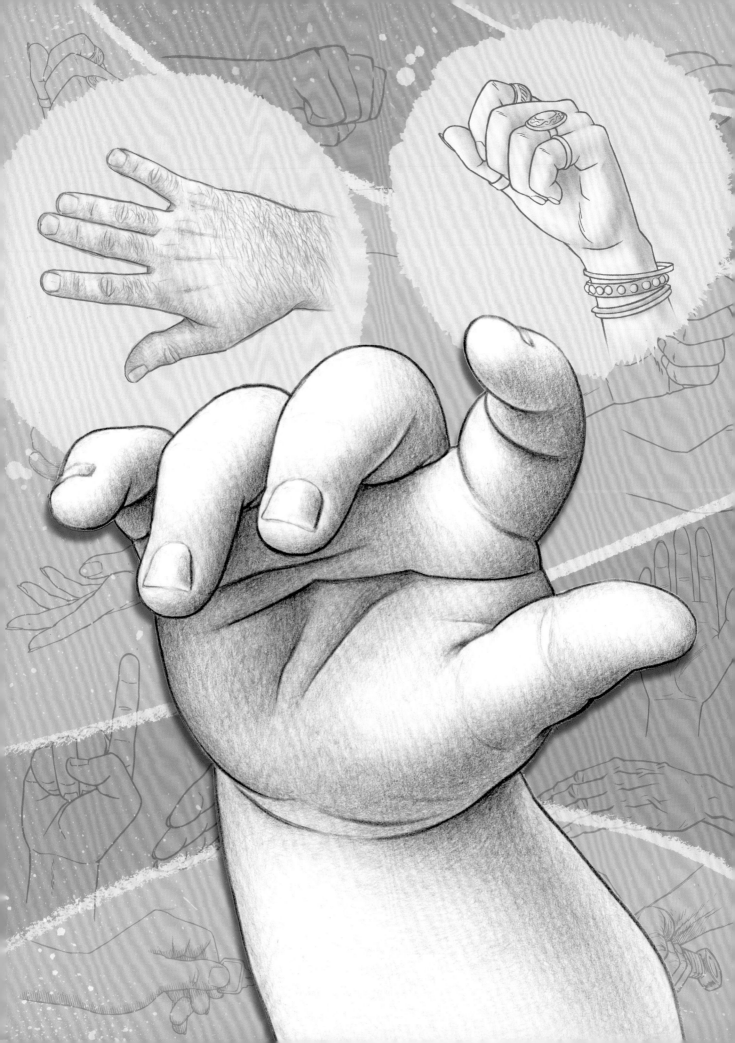

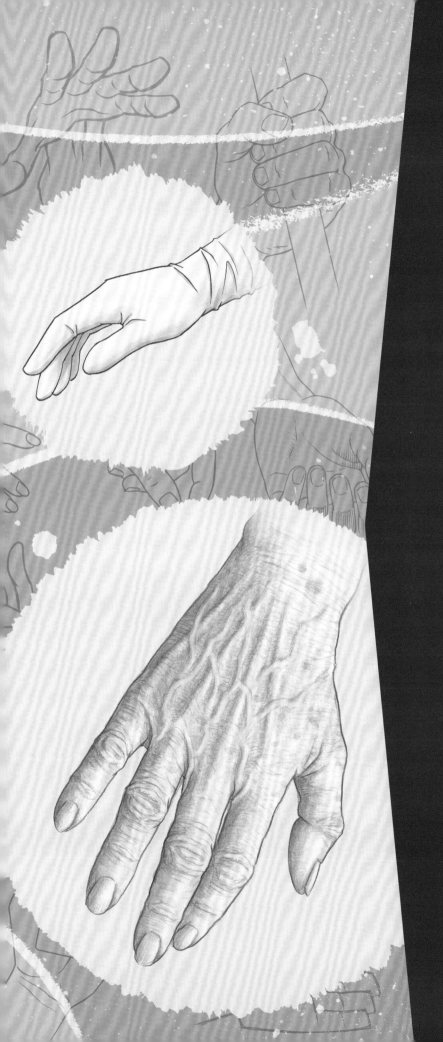

Hand Types

Books about drawing hands usually present a sort of "average hand" for all their examples, with the result being that all the hands you learn to draw look as if they belong to a twenty-year-old. Not so with this book. In the chapter ahead you'll learn about all the other types of hands you see on a daily basis: elegant hands, tough-guy hands, hands of the old and of the very, very young.

Not All Hands Are the Same

Now that you've familiarized yourself with the average adult hand, it's time to start looking at types of hands that are a bit more distinctive. Though every hand is formed from the same basic components, the proportions and surface details of hands vary widely.

In the pages ahead, you will learn about these differences and how to work them into your drawings. Let's begin by learning what makes feminine hands different from masculine ones.

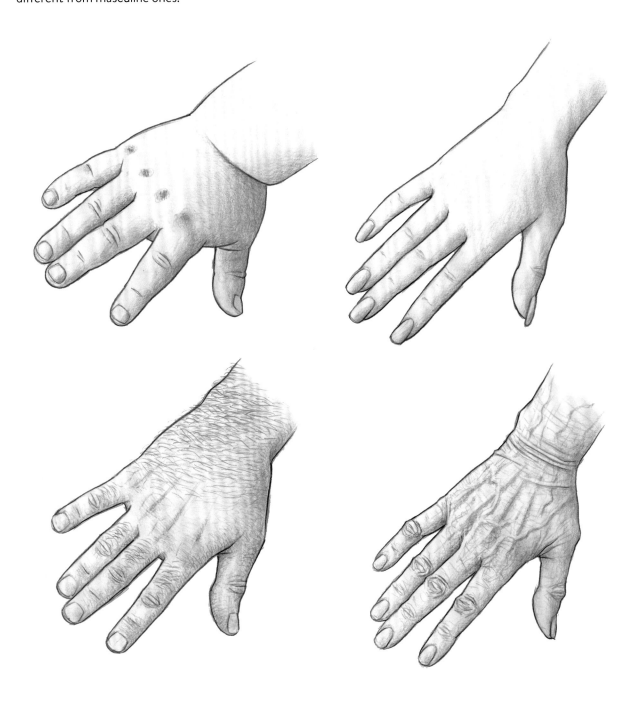

Feminine Hands

For the purpose of clarity, I've chosen to push the idea of a feminine hand to a slightly exaggerated degree. In the real world, of course, women don't walk around with their pinkies raised like a bunch of Cinderella princesses being asked to dance at the ball. But artists are sometimes called upon to draw such characters, and when we are, we need to know how to draw idealized, graceful hands such as the one in this lesson.

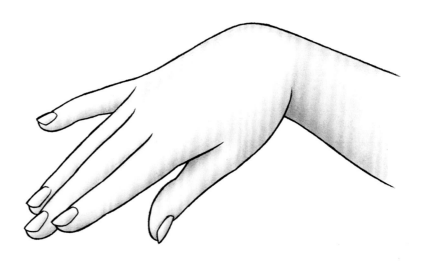

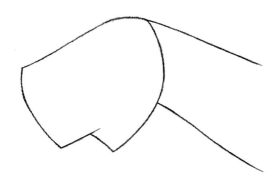

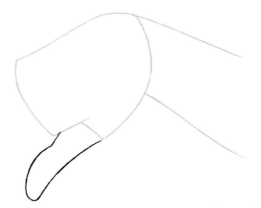

1 The Back of the Hand and Wrist
Start with the basic lines of the back of the hand and the wrist. Every line has a gentle curve to it. The upper contour line of the wrist flows so smoothly into the upper contour of the back of the hand that they essentially appear as a single, uninterrupted line. Be sure to leave plenty of space between the base of the thumb and the base of the fingers to allow room for adding the rest of the thumb in the next step.

2 The Thumb
When drawing feminine hands, the goal is to draw the hand with as few lines as possible. This economy of line is a huge part of what makes such hands appear elegant. In this lesson, the thumb is drawn with a single, flowing line. Still, there is a subtle indention in one of the lines, to reveal the two-part structure of the thumb.

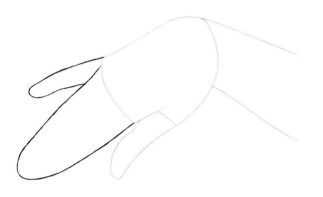

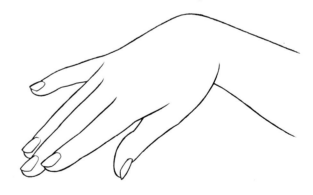

The Finger Guidelines

Add some basic guidelines to help with drawing the fingers. Since the pinky is going its own way in classic raised-pinky style, it needs to be drawn separately. Note that the upper contour line of the pinky flows, uninterrupted, from the contour line of the wrist and the back of the hand, extending that single line yet farther. The other fingers can be represented as a single mittenlike shape for now.

The Fingers

Divide the mittenlike shape into the three remaining fingers, starting with the index finger at the bottom. As always, knowledge of the relative lengths of the fingers is key: the middle finger is the longest, the other two are shorter by the same degree.

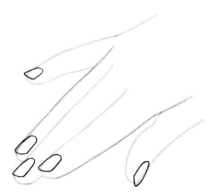

The Fingernails

While many of these lessons lead up to a step covering all the details, you could say that a feminine hand such as this one has no details at all. It is the absence of fussy extraneous lines that makes it look flawless, like the hand of an ancient Greek statue. When drawing the fingernails, pay attention to their location as well as their shape: they are all shifted to one side, to be consistent with the three-quarter point of view.

The Finished Drawing

Be sure to erase any guidelines from step 1 that might still be visible; this is especially important when drawing feminine hands. Of course this is just one pose. But try to use the principles of this lesson any time you need to make hands look feminine, regardless of the pose you're drawing. Use as few lines as you can, and keep those lines as smooth and clean as possible.

Masculine Hands

Again I have chosen to exaggerate details to show just how different a man's hands can be from those of a woman. Not every man you meet has "tough guy" hands like these, but as an artist you may be called upon to draw a character with such characteristics. After following this lesson, you'll be better prepared to take on such a job.

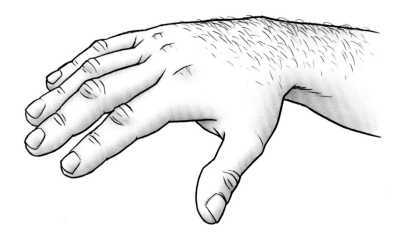

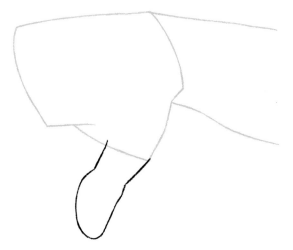

1 The Back of the Hand and Wrist

Right from the start we can see the difference between this hand and the feminine one from the previous lesson. The lines are more angular, a little less smooth. Note that the upper contour line of the wrist does not flow so smoothly into the one on the back of the hand: they can be two separate lines. When drawing the flesh near the base of the thumb, take care to have the contour line on the left overlap the one on the right.

2 The Thumb

Again, the way this thumb is drawn is markedly different from the thumb in the feminine hand. The lines meet to form angles. The division between the two halves of the thumb are much more visible here. As always, pay attention to proportions. The length of the thumb is similar to the width of the wrist.

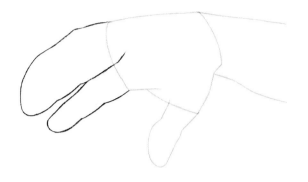

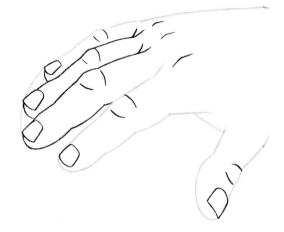

The Finger Guidelines

Definitely no pinky raising going on here! Instead, let's have the index finger slightly parted from the other fingers, in a relaxed way. Note that in the contour line of the index finger, you can see the three-part structure. This was certainly not the case in the feminine hand. A simple mittenlike shape will help lay the groundwork for drawing the other fingers.

The Fingers, Fingernails and Knuckles

Draw in the other three fingers, starting with the middle finger before moving on to the ring finger and the pinky. With a masculine hand, the fingernails are generally more boxy and angular than with a feminine hand. By drawing knuckles on each individual finger, we are making this hand distinct from most of the ones we have drawn thus far. It looks like a hand that has done plenty of hard work, or one that has seen a lot of action.

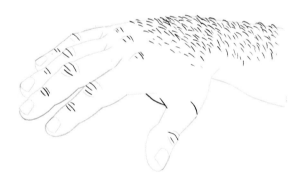

The Details

In many ways you could call the drawing finished at the end of step 4. But if you'd like to go 100 percent tough guy with your drawing, add dozens of little lines across the back of the hand to signify hair. Extra lines across the knuckles can make this hand look weathered and rough. A wrinkle or two where the thumb meets the palm can be a nice final touch.

The Finished Drawing

Take a moment to erase any remaining guidelines from steps 1 and 3. No doubt about it, this is the most distinctive of all the hands we've drawn so far. One look at this hand and you have a pretty good idea of what sort of guy it belongs to. Next time you need to draw a manly-man type of character, try applying some of these techniques to the way you draw his hands: angular lines, defined knuckles and indications of hair.

Female vs. Male Hands

In the preceding two lessons, we looked at hands whose masculine and feminine attributes were pushed about as far as they could go without becoming cartoonish. In our day-to-day lives, the differences between male and female hands are often much more subtle. Here are two side-by-side comparisons to help you see how an artist can avoid the extremes while still presenting hands that are discernibly male or female.

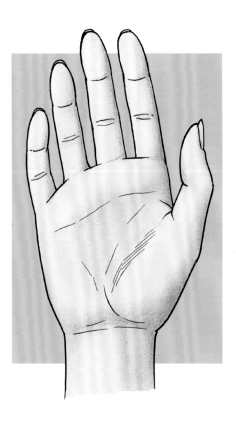
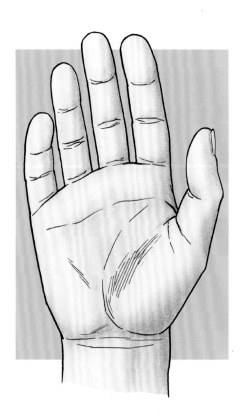

Example 1

The drawing on the left is pretty clearly female, but doesn't resort to exaggerations to get that point across. Yes, the fingernails are longer than is usually the case with men's hands, but this is merely the most obvious difference. Of equal importance is the narrowness of the wrist, and the slenderness of the fingers and thumb in general. The tips of the fingers are tapered a bit, almost pointy to a degree.

The drawing on the right is plainly male, and not just because the fingernails are shorter. The wrist is wider, the fingers and thumb are thicker, and the wrinkles are more sharply defined throughout.

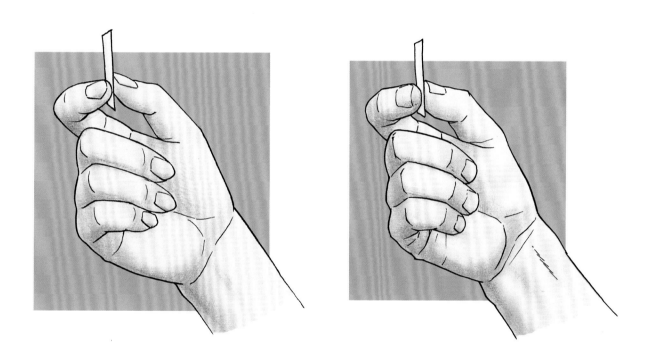

Example 2

Now we can compare a female and male hand performing the same action and in doing so see what changes and what stays the same. Once again, the narrowness of the female wrist on the left is crucial. The difference in the fingernails is easy to see, but pay attention to the contour lines of the hand as a whole. On the female hand the lines are clean and smooth, composed mostly of gently curving lines. The contour lines of the male hand on the right are much more angular looking. This line work alone can make a big difference in signaling to the viewer whether the hand is meant to be seen as a man's or a woman's.

Middle-Aged Hands

As people age, their hands age right along with them. If you're drawing a character who is meant to be forty or fifty years old, you will naturally devote a lot of care to showing age by way of wrinkles on the face. But you should also pay attention to how you draw the hands. This lesson will help you see just how the aging process affects hands as a person gets older.

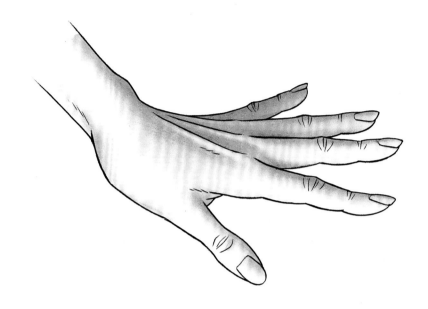

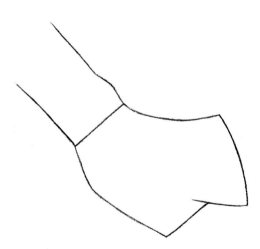

1 The Palm and Wrist

Begin with the palm and the wrist. In this early stage of the drawing, there isn't much that differs from how you might draw a younger person's hand. Note, though, that in the contour of the wrist we can see the ulnar styloid process (see page 52). As a person ages, the hands gradually become more bony looking, and that certainly applies equally to the wrist.

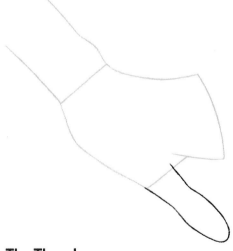

2 The Thumb

Draw the thumb. In this pose, we see the thumb directly from above, creating a contour that is more or less perfectly symmetrical. When drawing the thumb, pay attention to the proportions and to the angle in which it is pointing. It is heading in just the same direction as the wrist.

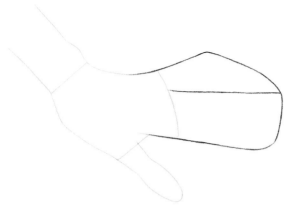

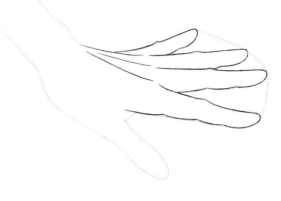

The Finger Guidelines

For this pose, the fingers are going to be widely spaced. Let's get some guidelines in place that will help us get them in the right place when it comes time to draw them in step 4. This guideline shape is a bit like a fish's tail with a horizontal line across the middle. Pay close attention to the proportions of this shape, making it wider than it is tall and replicating the curve of the contour line on the right.

The Fingers

Using this shape to guide you, begin drawing the individual fingers, starting with the index finger, then moving on to the middle finger, the ring finger and the pinky. Note that these fingers are much more angular than the ones in the "feminine hand" lesson (see page 58), reflecting the aging process. Now add lines that fan out across the back of the hand. These are indications of tendons, visible through the skin. As one ages, these tendons become increasingly easy to see.

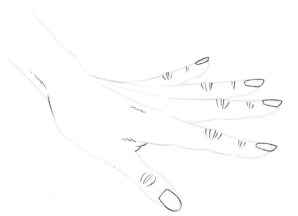

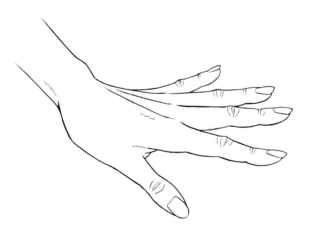

The Details

When it comes to drawing middle-aged hands, it's all about the details. These little final lines add many years to the apparent age of the hands. Note that the first knuckle of each finger—the one that is farther away from the fingertip—is larger and more pronounced than the one that is closer to the fingertip. Drawing lines on the knuckles increases the perceived age of any hand; such lines should be avoided when drawing younger characters.

The Finished Drawing

Go back and erase any guidelines that remain visible from steps 1 and 3. As you can see, a middle-aged hand is quite different than that of a younger person. But these differences seem almost negligible when compared to the really dramatic changes that can take place later in life. The next lesson is going to show you just how dramatic those changes can be.

Elderly Hands

When it comes to hands, perhaps the ultimate challenge is drawing the hands of an elderly person. As someone heads into their seventies, eighties and beyond, the skin of the hands no longer fully disguises what lies beneath. Tendons and veins become more visible, forcing artists wishing to draw such hands to become familiar with the interior anatomy. (Which you will be doing on the next page.) This lesson will show you every step needed in drawing the hands of an elderly person.

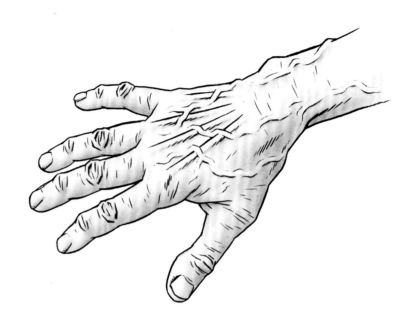

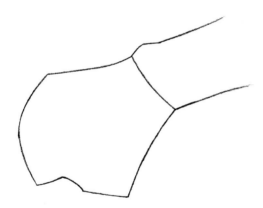

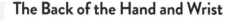

1 The Back of the Hand and Wrist
The first step is to draw the wrist and the back of the hand. As you can see, the ulnar styloid process is once again visible, right there where the upper contour line of the wrist joins the hand. Note that the wrist is quite narrow in proportion to the palm. This is typical of elderly hands of both sexes.

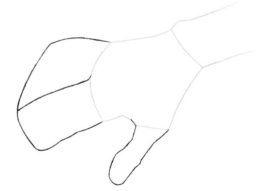

2 The Thumb and Finger Guidelines
Since there are many details to deal with in later steps, draw both the thumb and the finger guidelines now. As you would expect, the thumb is quite angular. No need for graceful, elegant lines here. With the fingers being spread out, another fishtail guideline is needed for the fingers (as seen in step 3 of the previous demo). This time the line across the middle—a guideline for the middle finger—is parallel to the contour line of the index finger.

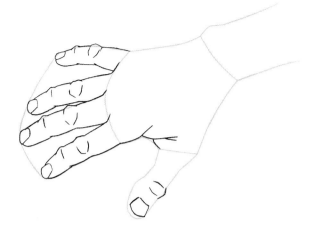

The Fingers and Thumb

Using the fishtail shape as your guide, draw all four of the fingers beginning with the index finger and working your way toward the pinky. The first knuckle of each finger (the one farther from the fingertip) is very prominent in an elderly person's hand, altering the contour of each finger substantially. Note also that the wrinkles where the thumb joins the hand are more pronounced than usual.

The Tendons

The details of the back of an elderly person's hand present artists with a challenge because the complexity of what lies beneath the skin is considerable. First you must draw the tendons, fanning out from the wrist, one toward each finger. (See pages 68–69 for a thorough explanation of the tendons and veins.) You may also add some lines in the area of the wrist to convey the structure in that area.

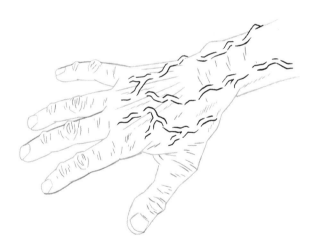

The Veins and Other Details

Once you've got the tendons in place, draw a network of veins that flows across them. I have highlighted these vein lines in purple to make them easier to see. Their pattern is different for every human being, so an artist can feel free to place these veins in almost any location. As you can see, I have finished my drawing with dozens of small wrinkles throughout, but they are by no means essential. The more you add, the older the hand will appear.

The Finished Drawing

If there are any guidelines remaining from steps 1 and 2, go back and carefully erase them. The challenge of drawing an elderly person's hand accurately might be the toughest lesson in the whole book. It does, however, have the benefit of teaching you the locations of the tendons and the veins, which is knowledge that can be helpful when drawing all types of hands. I have devoted the next two pages to covering this topic in greater detail.

The Back of the Hand

Many books covering the interior anatomy of the hand go into the subject in a thorough way, showing what every last bone in the hand looks like, as well as every muscle, tendon and vein. My goal with this book is to limit the interior anatomy instruction to just the ones that directly affect one's drawings of hands. The tendons and veins on the back of the hand are two such features.

If you want to draw the back of the hand properly, you will need to familiarize yourself with the tendons and veins that lie just beneath the skin. Happily, it's not so hard for an artist to memorize what's going on down there and begin working that knowledge into their drawings.

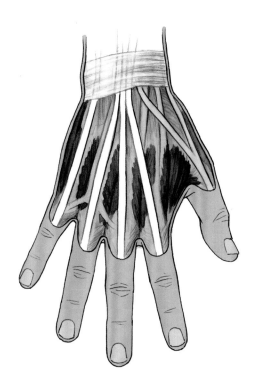

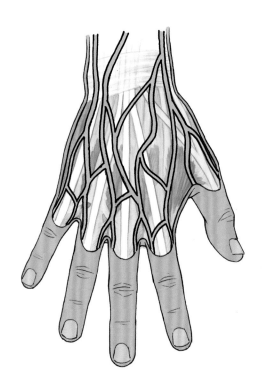

The Tendons

In this image, we have lifted away both the skin and the veins to examine just the tendons. As you can see, there are three joined together in the center of the wrist that lead toward the ring, middle and index fingers. A fourth one, off to the side of the wrist, connects to the pinky. If you look at your own hand and tense your fingers, you should be able to observe at least the middle three of these tendons.

The Veins

Here we see the same hand, but with the veins added on top. This is where age makes a difference between what you can see when looking at the back of your own hand and what lies beneath the skin. Only an elderly person will be able to see anything close to the complex network of veins that is illustrated here. For the majority of people reading this book, only a few of the veins will be visible—the rest are hidden beneath the skin.

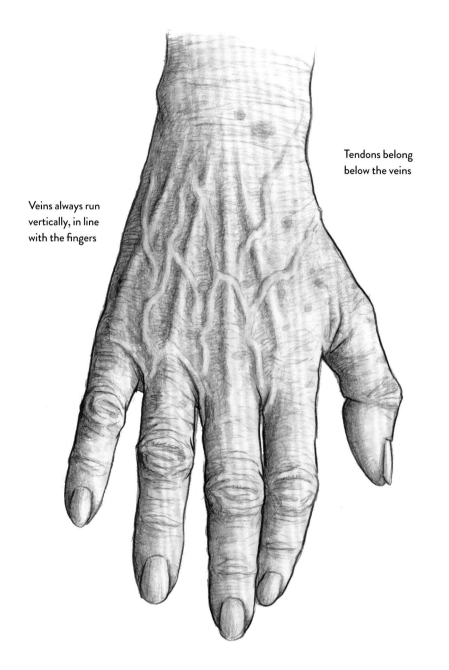

Veins always run
vertically, in line
with the fingers

Tendons belong
below the veins

Detailed Elderly Hand

Any realistic drawing of the back of
an elderly person's hand will involve
rendering both the tendons and the
veins. The challenge is to find a way
of showing the two different layers:
the tendons below and the veins
spreading across the top of them.

One thing to keep in mind is
that the tendons are generally a
bit thicker than most of the veins.
Note also that the directional flow
of the vein network in this drawing is
mostly vertically oriented, a little like
rivers flowing down a mountainside.
If you were to draw the veins
heading side to side, parallel to the
knuckles, it would look unnatural.

Simplified Elderly Hand

Of course, artists are very often
drawing hands as a small part of
a much larger illustration, and
tremendous detail is not always
possible, or even desired. In such
cases, a drawing of an elderly
person's hand needs to be greatly
simplified. With just a few carefully
placed lines, you can convey both
the tendons and the veins. The trick
is to include the tendons, but keep
the veins to a bare minimum.

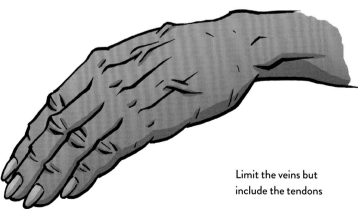

Limit the veins but
include the tendons

Children's Hands

It may be tempting to think that children's hands are the same as adult hands, only smaller. Alas, it is not true. When an artist draws children's hands, they must relearn many of the basic rules because they are drawn in quite a different way. Follow this lesson to learn what makes children's hands so unique from those of adults.

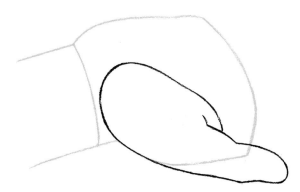

1 The Palm and Wrist
Start by drawing the palm and the wrist. You can already see how different the proportions are compared to an adult hand. The wrist looks quite small compared to the palm. And the palm is wider than it would be with an adult hand. The distance from the wrist to the base of the fingers is a bit shorter than we might expect.

2 The Thumb
Draw the thumb, this time including the part of the palm that it is attached to. This thumb's proportions are strikingly different from what they would be if we were drawing an adult's hand. It is shorter in length, and smaller in all other respects, given the size of the palm.

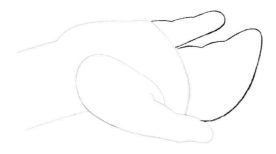

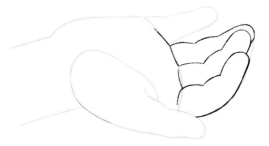

The Finger Guidelines

Let's draw some basic guidelines for the fingers. In this pose, the pinky is pointed in a different direction than the other fingers, so it needs to be drawn separately. Note how different it is from the pinky of an adult. It is thicker at the base and very short compared to the palm. Now draw a mittenlike shape that will lay the groundwork for the other three fingers, taking care to make the upper contour line divide into three curved sections.

The Fingers

Using the mitten shape as your guide, draw the three remaining fingers, starting with the index finger, then moving on to the middle finger and ring finger. Just like the pinky, these fingers are shorter and considerably fatter at the base than they would be on an adult hand. Their undersides are soft and puffy, and the fingertips seem almost to come to a point.

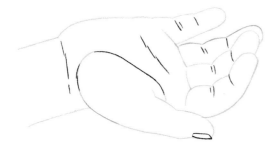

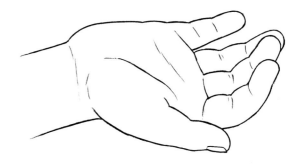

The Details

As was the case with feminine hands, drawing children's hands requires comparatively little in the way of detail. The main things needed are short lines across the breadth of each finger to show the three-part structure there. One or two lines across the palm can help to convey the surface there, and a thumbnail on the thumb is needed to finish off the drawing.

The Finished Drawing

Erase any guidelines that might remain visible from steps 1 through 3, and you're done. As you can see, the key differences between children's and adult's hands come down to proportions. In childhood, both the fingers and thumb are much shorter than they will eventually be in proportion to the palm. As an artist, you must keep this proportion difference in mind anytime you draw the hands of a child.

Rings and Bracelets

Now that we've covered all the main types of hands in this chapter, I thought I'd squeeze in one little lesson on a topic worth exploring: drawing hands that are adorned with bracelets and rings. Making such a drawing provides good practice in envisioning the various surfaces of the hand, since the rings and bracelets that you draw must follow along with those surfaces, appearing to rest upon them.

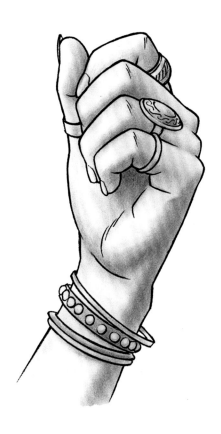

1 The Palm and Wrist

I've chosen a hand pose in which the fingers are drawn together loosely, not quite pulled into a fist. This requires drawing a shape that bears some similarities to a balled-up fist shape but less rounded. Note that the contour line on the lower right is quite straight (it delineates the back of the hand). When drawing the wrist, now is your chance to include the bump of the ulnar styloid process. You can see it there on the right side where the wrist meets the base of the palm.

2 The Finger Guidelines

Since the thumb is turned away from us, start with some basic guidelines for the fingers. Begin by drawing the index finger, which is perched atop the palm shape you drew in the previous step. Now draw a line that divides the palm shape into two parts: the fingers and the side of the palm on one side of the line, and the concave hollow of the palm on the other. Take your time, since it's a tricky line to draw.

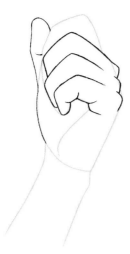

3 The Thumb and Fingers

Now it's time to draw the thumb using a line that splits off from the palm shape. Give the line an angle at its midpoint, conveying the two-part structure of the thumb. Now you use the dividing line you created in step 2 to begin drawing the remaining fingers. Start with the pinky, then work your way up to the ring finger and middle finger. Be sure to draw the contours of the knuckles on the right-hand side.

4 The Details

Draw fingernails wherever they remain visible: on the pinky, the ring finger, the index finger and— just barely visible—on the thumb. Add a few short lines across the fingers to accentuate the spots where the finger joints bend. If you like, you can add some extra lines below the pinky to emphasize the structure of the palm.

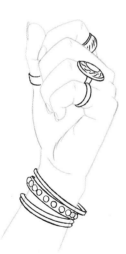

5 The Rings and Bracelets

Finally! Now we get to the fun part of getting a little fancy with this hand. When drawing the rings and bracelets, there's no need to replicate exactly what I've done here. Feel free to be creative and make them your own. The important thing is to have each item follow along with the surface of the skin. This means the rings curve to the right on all the fingers, while the thumb ring curves downward. The bracelets also curve downward— you can draw them tight on the wrist or hanging loosely.

6 The Finished Drawing

There shouldn't be many guidelines visible at this point, but if you see any cluttering up the drawing, now's the time to erase them. There you have it: a hand that any artsy-fartsy type would be proud of. Keep in mind that if you draw someone wearing a wristwatch, these same rules apply. The lines of the band of the wristwatch must curve to follow the surface of the skin beneath it.

Baby Hands

We've had a lesson on drawing children's hands, but what about the hands of a baby? Not surprisingly, they are even more different than a grown-up's hands, both in their proportions and surface details. Here are a few things to keep in mind when drawing the hands of infants and toddlers.

Dimple Knuckles
Baby's hands have dimplelike indentations across the back of the hand where you would expect the knuckles to be.

Short Fingers
The length of the fingers is extremely short in proportion to the palm. The middle finger can be as little as two-thirds the length of the palm area.

Baby Fat
Baby's hands are very puffy looking, including the area of the wrist. Imagine them as partially inflated with air, and your drawing will get the right look.

Gloves

As this chapter draws to a close, I wanted to sneak in one page devoted to drawing people wearing gloves. In some ways, drawing a hand wearing a glove may be considered easier than drawing the hand itself—you are freed, at least partially, from the rigors of rendering the anatomy accurately. Still, drawing gloves is not without its challenges. Here are some tips.

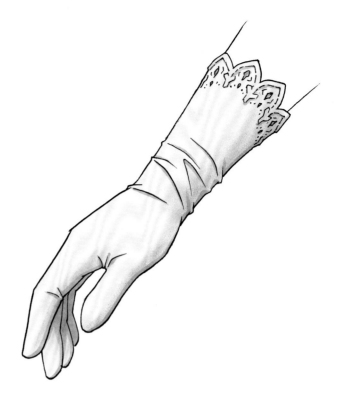

Formal Wear Gloves

Formal wear gloves are typically delicate, made of the lightest possible material to fit the hand as snugly as possible. Note that wrinkles tend to form in the area of the wrist, their lines moving horizontally across the wrist, rather than running lengthwise.

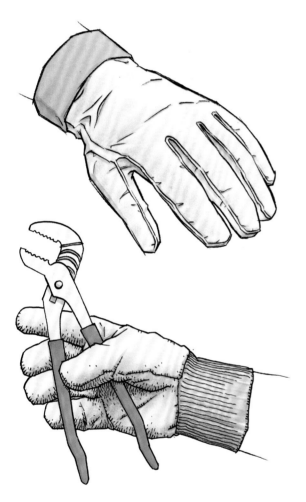

Work Gloves

When drawing work gloves, you must choose hand poses that convey the limited dexterity such gloves allow. The thick, leathery material forces the fingers to take hold of objects in a more simplistic way than a typical gloveless hand.

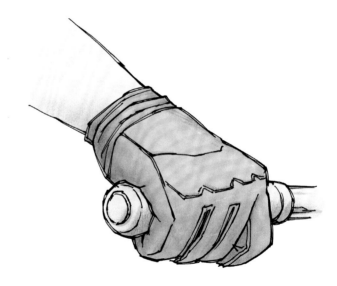

Biker Gloves

Biker's gloves are somewhere between the two extremes of work gloves and formal wear. The thick material doesn't follow the form of the hand quite so snugly as a formal wear glove, but it allows for a somewhat more delicate pose than that of a work glove.

Stylized Hands

Now that you've drawn a wide variety of hands, it's time to take things to the next level. In this chapter, you'll learn how cartoonists and comic book artists apply their own specific styles to the task of drawing hands. The result will be some of the most memorable and visually interesting hands you've ever drawn.

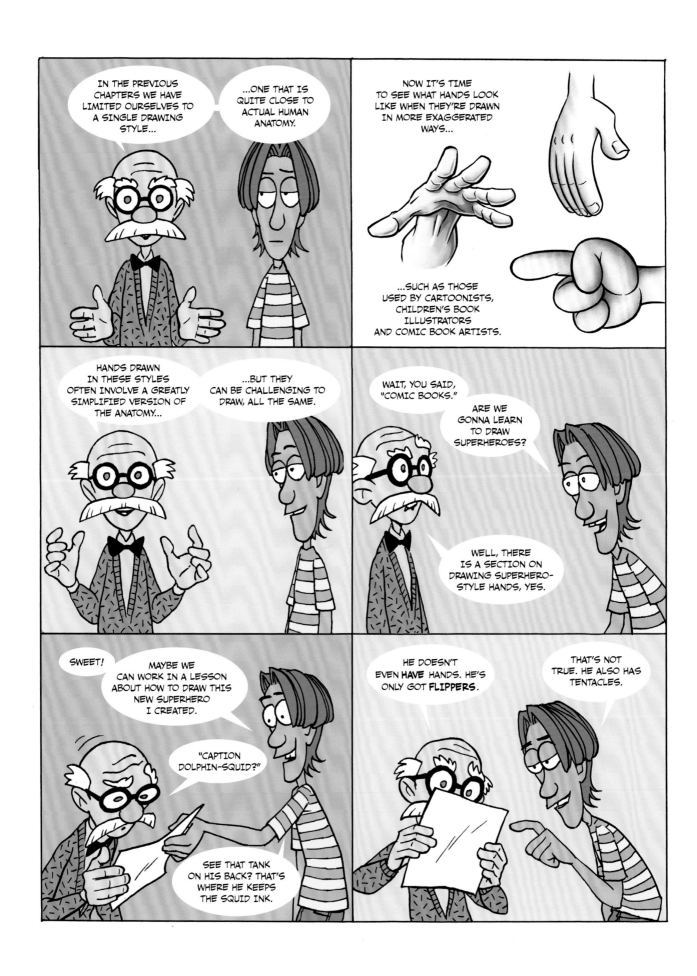

A Style for Every Artist

Thus far we have limited our focus to a study of hands drawn in a realistic, representational style. Now it's time to have some fun and examine what hands look like when they're drawn in more fanciful ways. The truth is there are as many different ways of drawing hands as there are cartoonists willing to experiment. Here are just a few examples.

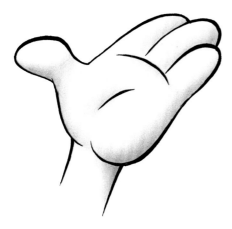

Three-Fingered "Disney" Hand
A classic! Nothing says "cartoony" quite like three fingers.

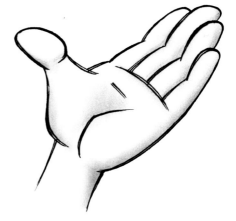

Four Fingers But Still Cartoony
Many artists prefer this moderate approach.

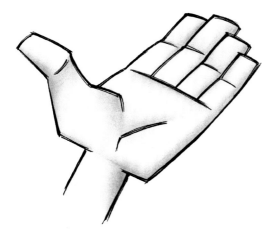

Boxy Hand
Adding angles to a hand can help give it a visual zing.

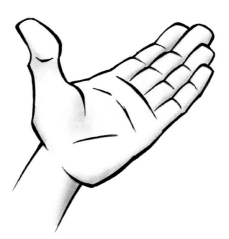

Quasi Realistic
Some cartoonists go for a more detailed approach—just one or two steps away from accurate anatomy.

Slightly Cartoony Hands

Having stuck with realism for the first three chapters of this book, let's ease our way into cartoony-ness by way of a hand that is at least somewhat close to actual human anatomy. That means, at bare minimum, four fingers. (If you're one of those folks who is eager to go "full cartoon," be patient: we'll get there in the next lesson.) Is drawing a cartoony hand easier than drawing a realistic hand? Only one way to find out!

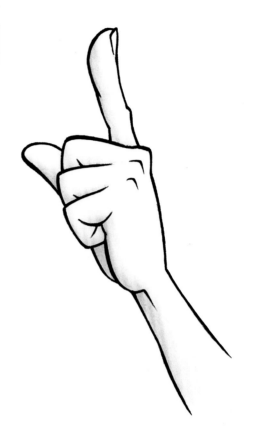

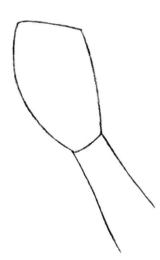

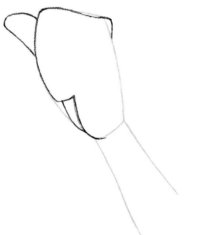

1 The Palm and Wrist
I've chosen to do a pointed finger, so that means starting with a shape that can be used for both the palm and the three fingers that are folded in on themselves. Note that the contour on the right-hand side, delineating the back of the hand, is not nearly as curved as the contour on the left. Cartoony hands are often very large in proportion to the wrist, so pay attention to size comparisons when drawing the wrist lines.

2 The Finger Guidelines and Thumb
Add guidelines to lay the groundwork for drawing the fingers. Starting at the upper-right corner of the palm shape, draw the contour of a knuckle. Then extend this line to the left, following along the guideline shape until you reach the lower left, where you can draw the contours of the base of the palm. Add a single curving line on the upper left to serve as the contour of the thumb.

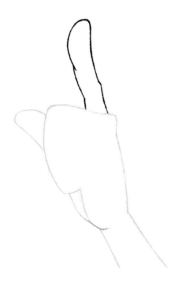

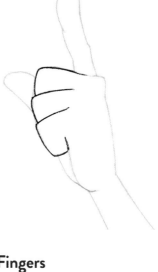

The Index Finger

Now we can get into some of the really cartoony stuff. While an actual human finger tends to taper a bit as it reaches the tip, a cartoon finger—especially when it's an index finger—tends to do the opposite: it expands a bit near the tip. Note that there is a small protrusion in the contour line on the right-hand side. This is an indication of the knuckle.

The Fingers

Now you can take the guideline shape you created in step 2 and begin dividing it up into the three remaining fingers. Note that each of the fingers points in a slightly different direction. This creates a more natural appearance than you would get if you drew all the fingers parallel to one another.

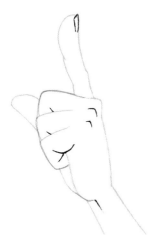

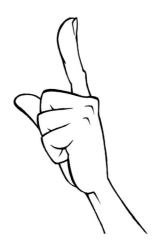

The Details

As you might have guessed, a cartoony hand has fewer details than a realistic one. Still, the ones it includes are important. The Y-shaped line in the area of the pinky helps show the three-part structure of that finger. Adding two more knuckle lines adds a sense of three-dimensionality to the back of the hand. While many cartoony drawings of hands don't bother with fingernails, I thought this one would benefit from that last bit of detail.

The Finished Drawing

You shouldn't have much in the way of unneeded guidelines that remain visible, but if you see any still hanging around from step 1, go ahead and erase them now. So what do you think? Are cartoony hands easier to draw than realistic ones? Personally, I think it's helpful to be able to draw them both ways.

Very Cartoony Hands

All right, enough messing around. Let's dive into the deep end of cartoony-ness, already. To me, this means moving from four fingers to just three. By eliminating one of the fingers, space is freed up to make each remaining finger fatter, rounder and just plain cartoonier. Heck, if it's good enough for Mickey Mouse and Bart Simpson, it's good enough for me!

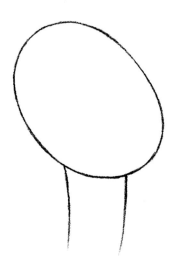

1 The Palm and Wrist

Most cartoony styles gravitate toward rounded shapes. By streamlining everything into curves and circles, your characters begin to take on a bouncy, rubbery quality. And so it is that we get to what is surely the easiest step 1 in the book. Still, you should pay attention to the tilt of the oval palm shape, as well as the width and placement of the wrist.

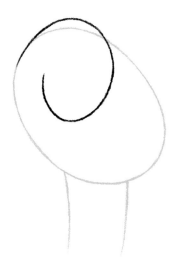

2 The Finger Guideline

Let's get in a guideline that will help us place the fingers later on. When drawing this single, spiraling line, pay attention to where it falls within the oval of the palm. At its lowest point, it extends to roughly dead center of the oval. Its highest point strays just outside the upper edge of the oval.

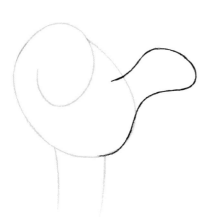

The Thumb

Cartoony thumbs require a smooth, confident line; ideally, one that is drawn with a single stroke. When drawing this shape, take care to get the angle right. It is pointing diagonally toward the upper right. Proportions are important, too. At its widest, the thumb is nearly as wide as the wrist.

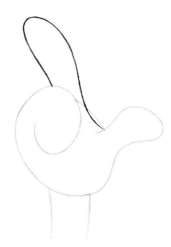

The Index Finger

Now you can really see that "rubbery quality" I was talking about earlier. If you didn't know it was an index finger, you'd think it was the head of a rubber snake! Again, the direction of these lines is important. Together with the thumb, they form a ninety-degree angle.

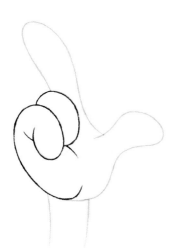

The Remaining Fingers

Making use of the guideline from step 2, draw the remaining fingers, starting with the pinky, then moving on to the ring finger. (Or is it the middle finger? I'm so confused!) As with all the other steps in this lesson, smoothness of line is crucial. A master cartoonist does every line with a single stroke, never going over it a second time.

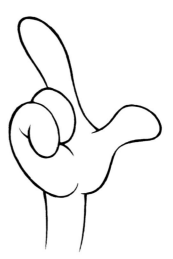

The Finished Drawing

If you see any unwanted guidelines from steps 1 and 2, erase them now. We've taken this drawing to the limit! This drawing is as cartoony as this book is going to get, and in the subsequent lessons we'll be exploring styles that are a bit more grounded in real human anatomy. But first, let's have a closer look at cartoony hands, and the stylistic choices that lie behind them.

Cartoony vs. Realistic Hands

Drawing a cartoony hand involves greatly simplifying the anatomy of the human hand. But what exactly is being changed? Which details are being eliminated, and which aspects remain the same? To answer these questions, let's do a side-by-side comparison.

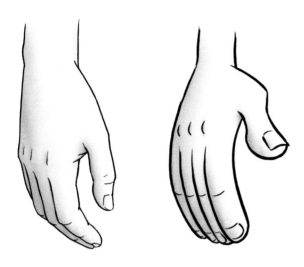

Combine Parts of the Hand
A cartoonist may take the palm and the fingers and combine them into a single, flowing shape. The contour of the thumb is often made much more bold than it is in real life.

Eliminate the Joints
The fingers and thumb may appear to have no joints at all, bending and curving as if they were made of flexible plastic.

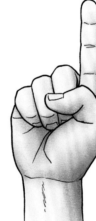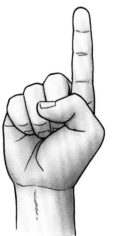

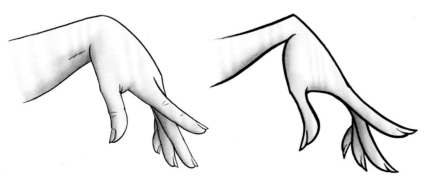

Feminize the Features
A cartoony female hand often has long slender fingers, with fingernails that come to a point. The wrists can be exceptionally tiny, even by cartoony standards.

Making It Rubbery

One of the keys to drawing cartoony hands well is figuring out how to give them a certain stretchy, rubber-like quality. Imagine old animated films, in which cartoon characters squish down and bounce back like rubber balls. Here are some tips.

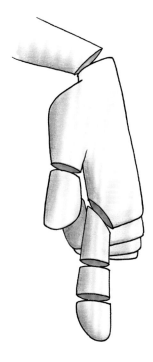

1 Basic Components
When you want to draw a cartoony hand, try envisioning the basic components of the hand as if they were split into different pieces. You don't have to draw it this way; just try to picture such a hand in your mind.

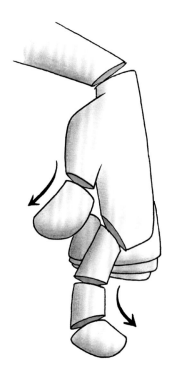

2 Push the Components
Prior to drawing the hand, think about how the different components could be pushed in one direction or another. Imagine how the fingers or the thumb might bend or stretch.

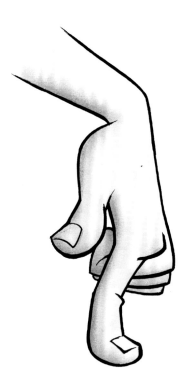

3 Create Elasticity
As you sit down to draw, recall the various components of the hand and mentally push them in the direction of elasticity. If the thumb or the fingers in your drawing still look stiff, erase them and push it even farther.

Fantasy Hands

Now that we've given cartoony hands their due, let's turn our attention to the world of fantasy. Whether you're working on a retelling of a classic fairy tale, or launching a comic book project inspired by *The Lord of the Rings*, you will soon find yourself drawing mystical creatures of one kind or another. Dwarves, elves, goblins and trolls—they are all humanoid to some degree, and they all have hands, naturally enough. Illustrators have a tradition of drawing such hands in a way that straddles the line between realism and fantasy.

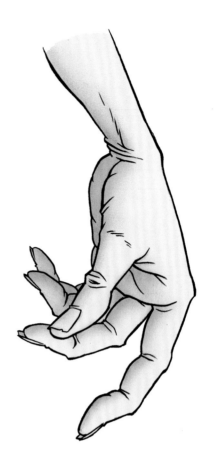

1 The Palm and Wrist
Let's start with the palm and the wrist, as we often do. Already, though, you can see we're heading into new territory. The wrist is exceedingly narrow, and the palm shape seems more than a little elongated. When drawing the shape of the palm, keep the contour line on the right fairly straight, since it needs to represent the back of the hand.

2 The Thumb
In this pose it is helpful to see the thumb joined to the base of the palm, and to draw it as a single continuous shape. Fantasy hands often have long spindly fingers and thumbs, and that is certainly the case in this lesson. Note that the tip of the thumb nearly comes to a point.

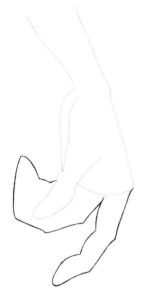

3 The Finger Guidelines

Now we should get some guidelines in place for the fingers. This pose requires you to draw an index finger that is widely separated from the other fingers and divided quite clearly into three phalanges. Once you've got that in place, draw a single guideline shape for the other three fingers. It should mirror the index finger to some degree, bending at two visible points.

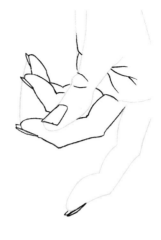

4 The Fingers, Fingernails and Wrinkles

Using the shape you drew in step 3 to guide you, draw the remaining three fingers, starting with the middle finger and working your way toward the pinky. In this pose the fingernails are visible, but only as slivers. The thumbnail needs to shift to the left to match the orientation of the thumb. Add a few wrinkles into the area where the thumb joins the palm.

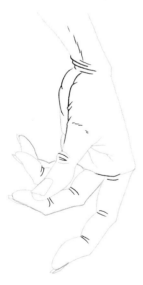

5 The Details

In many ways the drawing could be considered finished, but why not take it to a higher level with a few more details? Add short lines to the undersides of the fingers, emphasizing their three-part structure. Wrinkles at the wrist, the base of the palm and across the thumb's knuckle can give this fantasy hand some interesting final touches.

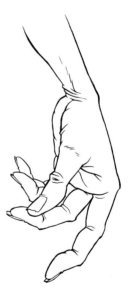

6 The Finished Drawing

There may be a few guidelines left over from steps 1 through 3, so take a moment to carefully erase them. As always, I was only able to teach a single pose in this lesson, but if you're interested in drawing fantasy creatures, try applying some of what you learned here to other hand poses. A narrow wrist and long, spindly fingers can be all it takes to give any hand pose a fantasy makeover.

Superhero Hands

Superheroes have been popular for many decades, but thanks to Hollywood, they are now a bigger part of mainstream culture than ever before. If you are familiar with the comics that all these superheroes came from, you know that they contain artwork that is truly spectacular in every sense of the word. So I was eager to devote at least a few pages of this book to superhero hands and what it is that makes them unique.

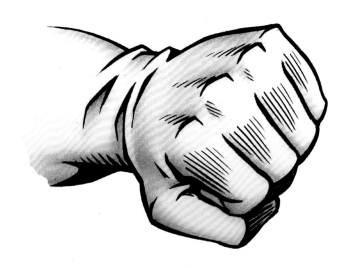

1 The Palm and Wrist

For this lesson I've chosen a hand pose that no decent superhero story could do without: a clenched fist, flying into action. This means starting with the ball of the fist, which in this case might better be described as the "hexagon of the fist." When you draw it, pay attention to the length of each line and the angles at which they meet one another. In keeping with superhero anatomy, the wrist is more muscular than usual, widening considerably as it heads toward the forearm.

2 The Finger Guidelines

Draw a rectangular shape across the fist to serve as a guideline for the fingers. The placement of this shape is important: any inaccuracies in this stage will throw off the proportions of the fingers in step 3. Pay attention to the empty spaces created on three of its sides as it fits within the shape of the fist.

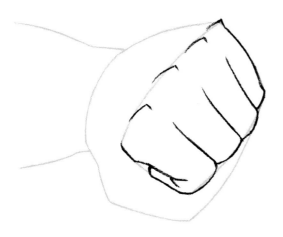

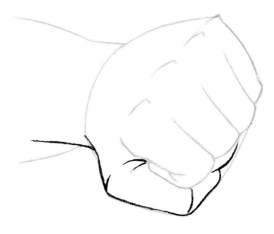

The Fingers

Take the shape you drew in step 2 and divide it into the four fingers, beginning with the index finger, which folds tightly in on itself. Note that the pinky is noticeably narrower than the other fingers. Then add the four knuckles, taking care to have them line up with each of the fingers.

The Thumb

Now draw the thumb, making its contour follow the fist shape you drew in step 1. Add a horizontal line that extends into the area of the wrist. This line will add to the muscular appearance of the forearm. One or two curved lines where the thumb joins the palm can convey wrinkles in that area.

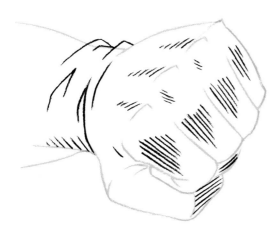

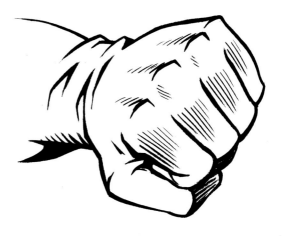

The Details

Much of this step comes down to personal preference. I've chosen to add a lot of lines across the fingers, which is an illustration technique that comic book artists have used for many years to add intensity to the drawing. I also included wrinkles around the area of the wrist, suggesting that this is a gloved fist, and part of a superhero costume.

The Finished Drawing

Take a moment to erase any guidelines that may remain visible from steps 1 and 2. If you like, you can also beef up some of your line work. There is a long tradition in superhero comics of drawing with bold, thick lines: it's one of the things that makes comic book art so dynamic and memorable.

Male and Female Superhero Hands

Superhero hands occupy an interesting place stylistically. They are certainly not cartoony, but they're not entirely realistic, either. The idea seems to be that superheroes need hands that are just a little more majestic than those found on mere mortals. Here are some examples of male and female superhero hands, along with tips to help you learn from them.

Male Hand at Rest
Dynamism is paramount. Even a hand at rest looks as if it is poised for action.

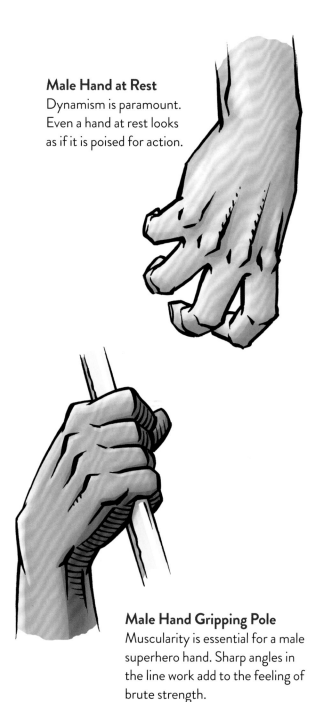

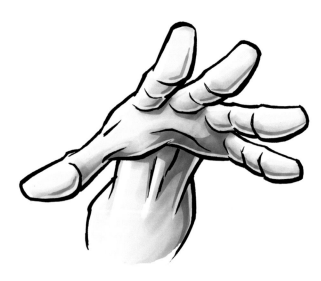

Male Fingers Splayed
This hand pose is a superhero classic. Fingers splayed and facing toward the viewer, it seems almost to reach up and out of the page it's drawn on.

Male Hand Gripping Pole
Muscularity is essential for a male superhero hand. Sharp angles in the line work add to the feeling of brute strength.

Male Hand in Flight
When superheroes take flight, they usually adopt this pose: fingers and thumb forward, everything as aerodynamic as can be.

Female Hand in Flight

When drawing a female hand in flight, comic book artists tend to make the fingers taper to a point, and they place less emphasis on the knuckles.

Female Fingers Touching the Ground

This is another classic superhero hand pose. Fingers touching the ground as our fearless hero prepares to leap into action.

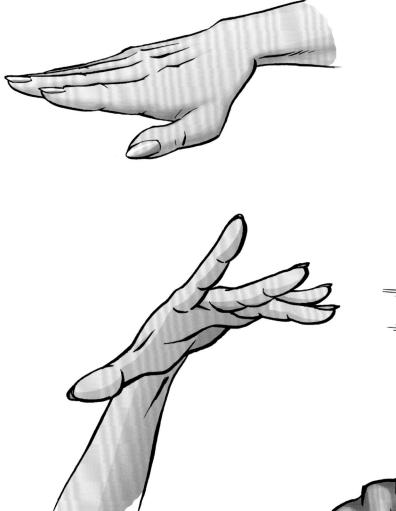

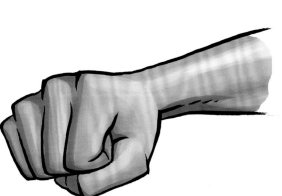

Female Fingers Splayed

A variation on the male fingers-splayed pose. As is so often the case, the female version presents a narrow wrist, and fingers that taper to a point.

Female Fist

Compare this to the male clenched fist of the preceding lesson to see how it differs. The wrist is narrower and the line work a little less angular.

LESSON

Monster Hands

When someone sets out to create a book about how to draw hands, the natural assumption is that it will be all about human hands. But sometimes an artist is called upon to draw hands on creatures that are decidedly not human. In this lesson we'll learn how to draw a monster's hand, and perhaps find that it is not so different from a human hand after all.

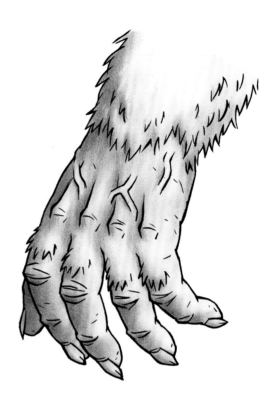

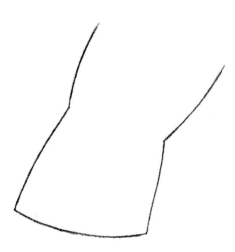

1 The Back of the Hand and Wrist

The monster hand that I've come up with is similar to that of a gorilla. To get started, we need to draw both the wrist and the back of the hand as a single shape. When drawing this shape, pay attention to the width of the space between the lines, and to the way that width is slightly reduced in the area of the wrist.

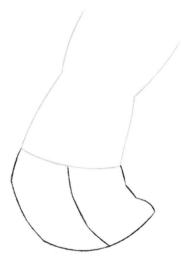

2 The Finger Guidelines

Now let's get some guidelines in place for the fingers. Add a mittenlike shape below the back of the hand that curves gently to the right. Note that this shape is wider than the back of the hand by a considerable degree. Then draw a curving vertical line up the middle.

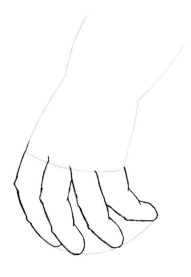

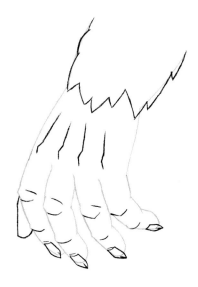

The Fingers

Use this shape to help you place the four fingers, allowing the vertical guideline to serve as the left-hand contour line of the ring finger. When drawing a monster's hand there is no need for perfection in the lines. Feel free to make your lines rough and jagged if you like: it'll add to the whole beastly vibe of the illustration.

The Fur, Tendons, Knuckles and Nails

Adding fur is strictly optional; leave it out if you prefer. Note that I drew four lines across the back of the hand as indications that there are tendons beneath the skin. Artists often rely upon their knowledge of human anatomy to give monster drawings an authentic look. When drawing the fingernails, have fun. They can be claws, or talons, you name it. Don't forget to add the thumb next to the index finger.

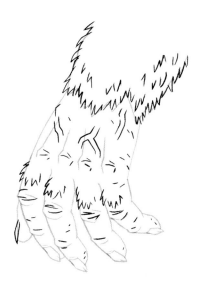

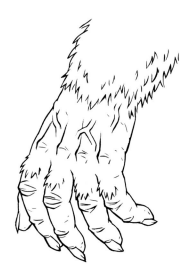

The Details

Now you can get into the fun of adding monster-y details. For me, that meant plenty of fur on the forearm and a bit on the first phalange of each finger. Since we've already got the tendons in place, why not add a few veins on top of them? Horizontal lines across the knuckles are a good way of suggesting wrinkled flesh in those areas.

The Finished Drawing

If any unwanted guidelines remain from steps 1 and 2, carefully erase them now. As you can see, knowledge of human anatomy can be super helpful in adding a dimension of realism to a drawing of a monster's hand. By including tendons and veins, the whole thing becomes just a little more believable.

Alien Hands

When an artist is asked to draw a monster, they may choose to give the beast a pair of hands that are modeled fairly closely on human hands, as we have just seen. But what if the assignment is to draw a being from another planet? In such a situation, limiting yourself to four fingers and a thumb just seems a little too timid. For this lesson, we'll see what happens when you stretch the definition of the word "hand" to include something truly alien.

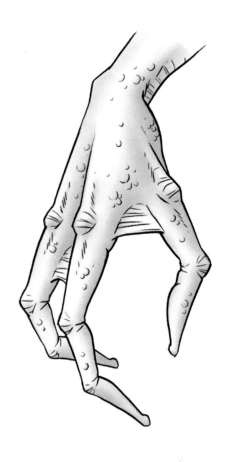

1 The Palm and Wrist
The fun thing about drawing an alien is that no one can tell you you're doing it wrong...you're inventing the thing, after all. So feel free to be creative and alter every step of this lesson as you see fit. I've chosen to give my alien a narrow wrist and a back of the hand that widens as it extends toward the fingers. Note that I've included a little bump in the contour of the wrist. An alien ulnar styloid process?

2 The Thumb
People may debate whether creatures on other planets have opposable thumbs, but I like the idea of a two-finger, one-thumb arrangement. It's alien but still understandable in terms of its functionality. And while this alien hand seems bizarre at first glance, it is similar to a human hand in at least one respect: the thumb has one less joint in it than the fingers.

The Index Finger

Now we come to the first of the two fingers. Elongated and somewhat froglike, it nevertheless has the three-part structure that we see in human fingers. By including protrusions at the joints—an indication of knuckles—we can give some sense of there being a bone structure beneath the skin. Such realistic touches help make the drawing more believable as the hand of a living creature.

The Remaining Finger, Knuckles and Webbing

I'm not sure what this other finger should be called, but I vote for "the pinky." By having it echo the pose of the first finger but not replicate it exactly, we can give the hand a more naturalistic look. Webbing between the fingers and thumb is a tried-and-true way of making the hand look more otherworldly than human.

The Details

Now that you've got the basic structure in place, you can get into the details. I wanted my alien creature to have lizardlike skin, so I added lots of small crescent-shaped lines to convey a reptilian texture. Horizontal lines across the knuckles, webbing and the underside of the wrist add a contrasting "banded" texture. As with all the other steps in this lesson, feel free to play around and make it your own.

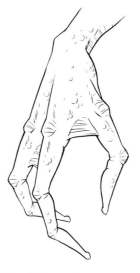

The Finished Drawing

Carefully erase any remaining guidelines from step 1. We went on quite a journey in this chapter, covering everything from Mickey Mouse hands to the hands of alien beings. Still, they all have something in common: they are adapted from the human hand to some degree. Knowledge of real human anatomy adds authenticity to any illustration of a hand, no matter how fantastical it may be.

Monster Hands

Not all monster hands are hairy and gorillalike. Many artists prefer to give creatures much more human-looking hands. Here are a few such hands for you to examine, along with some final drawing tips.

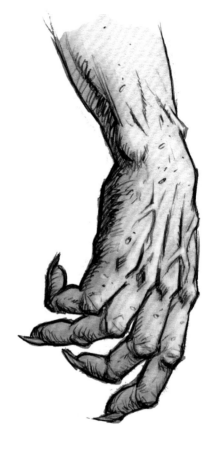

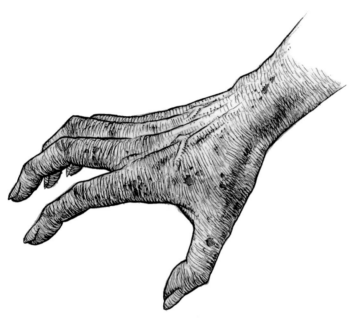

Zombie Hand
The anatomy of a zombie's hand, such as this one, can be modeled very closely on that of an ordinary human hand. In such cases you may instead turn your attention to the surface of the skin, giving it a rotting, leathery appearance.

Creepily Curled Fingers
In many cases it is primarily the pose that makes a hand look threatening. By making the fingers curl around and point in seemingly random directions, you can give a hand a creepy, unsettling appearance.

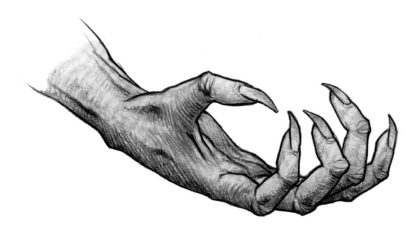

Claws
Sharp, clawlike nails can make a huge difference in how threatening a hand appears. The viewer can't help but imagine the damage such nails could cause. Yikes!

Robotic Hands

Part of the fun of this chapter for me has been expanding the definition of hands to encompass the widest possible range of topics. Having looked at monster and alien hands, I knew I had to devote at least a page to the hands of robots. Of course, they don't necessarily have to bear any resemblance to human hands at all. But when they do, it's interesting to see what it is they have in common with the fleshy hands they're based on.

Focus on the Joints
If you want a robot you've drawn to look believable, you need to give some thought to how its joints move. This robotic hand has a ball joint at the wrist, allowing it maximum flexibility.

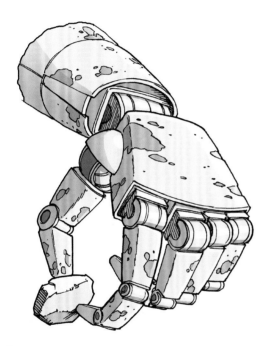

Add Rust
As a big *Star Wars* fan, I love drawing robots that have a rusty, scuffed surface to them. This hand is actually pretty closely based on a human hand, its thumb having two segments, and its fingers having three.

Humanoid Hallmarks
Many artists prefer to draw a sleek, streamlined sort of robot. This can result in hand designs that are very human-looking, indeed, seemingly capable of mimicking any pose that a human hand could take on.

Hands in Action

The real key to getting better at drawing hands is to draw them in the act of getting something done. Every time you draw a hand in the midst of a specific task, such as opening a door or playing a violin, you learn something new about the versatile structure of the human hand and how all its parts fit together. In this final chapter, you will learn about a huge variety of hand poses, all of them relating to the performance of common, everyday tasks.

The Importance of Practice

No one gets better at drawing without practice, but in the case of drawing hands, it is especially crucial. You simply can't come to understand the structure of the human hand without drawing hands over and over, in every type of pose you can imagine. Here are some tips on getting the most out of your drawing practice.

Use Your Own Hand As a Model

You've got a ready hand model right there at the end of your wrist, so go ahead and put it to work. If you're having trouble holding the pose, take a photo and then use the photo for reference. To get an angle on your hand that you can't normally see, stand in front of a mirror and use the reflection as a model or as a source of reference photos.

Do Studies of Drawings by Professional Artists

If you know of an artist who draws hands really well, don't just sit there admiring them. Do careful copies of the hands in their illustrations. These artists can serve as your teachers, showing you helpful shortcuts for drawing hands, techniques that you can then carry over into your own work.

Fill a Sketchbook with Drawings of Hands

If you follow every step-by-step lesson in this book, you will complete more than thirty drawings of hands. But that is far from enough if you really want to become a master of the subject. Challenge yourself to draw five or ten hands each day, and keep at it until you've drawn hundreds of them. If you continue this for weeks or months, you are going to see real progress in your abilities. I guarantee it.

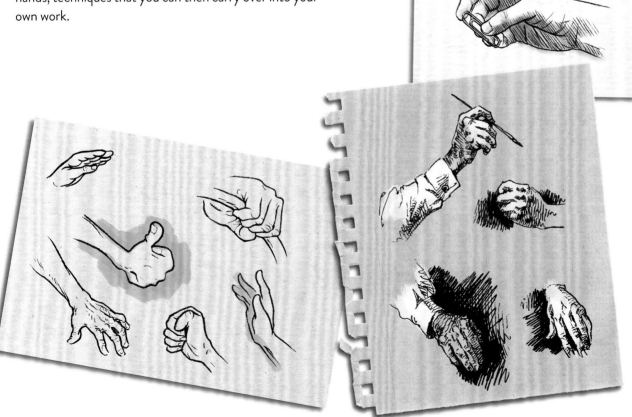

Hand Holding a Pencil

For this chapter's first lesson, I can think of no subject more appropriate than a hand holding a pencil. After all, any time we sit down to draw we are doing exactly that. And yet, it can be an awfully tricky pose to draw. Where do the fingers go? How does the pencil fit into it all? Here's a step-by-step lesson to help you out.

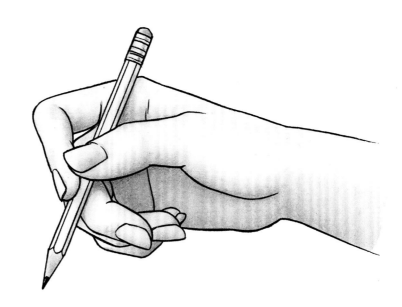

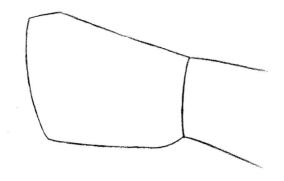

1 The Palm and Wrist

Begin by drawing the palm and the wrist. The upper contour line of the palm shape represents the back of the hand as it leads up to the knuckle of the index finger. The angle you see at the upper left is the knuckle. Note that the width of the palm shape grows larger the farther it gets from the wrist.

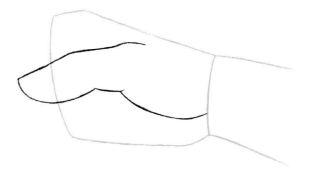

2 The Thumb

When drawing the thumb, pay attention to the straightness of the upper contour line as compared to the curving shapes of the lower contour line. The lower surfaces of the thumb are cushioned with padding, while the upper surface is much more flat and lean. In this pose, the thumb joins with the base of the palm to form a single shape.

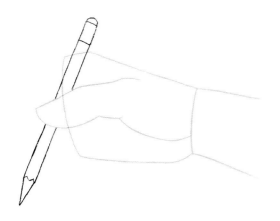

The Pencil

Before moving on to the fingers, let's get the pencil in place. When drawing the pencil, be careful to note its angle: diagonal, but much closer to vertical than to horizontal. There is no need to copy the details of this particular pencil. Indeed, you could change it to a pen or digital stylus if you prefer.

The Finger Guidelines

When a hand holds a pencil for the purpose of writing or drawing, the grip upon the pencil is maintained chiefly by the thumb and index finger. As a result, the index finger needs to be drawn separately from the other fingers, angling down to rest upon the side of the pencil. A single curving guideline shape can help with placing the other fingers in the next step.

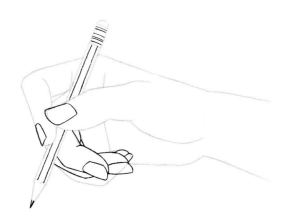

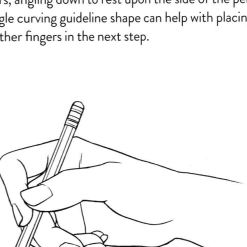

The Details

Continue by drawing the remaining fingers, beginning with the middle finger. As you draw the ring finger and then the pinky, make each finger bend slightly more than the one preceding it. When drawing the fingernails and the thumbnail, take care to accurately render their shapes: straight on the sides, curved at the tips.

The Finished Drawing

Use your eraser to get rid of any remaining guidelines from steps 1 and 3. Remember that everyone holds a pencil in a slightly different way, some of them quite different from what you see here. But this is a good one to use when you need a pencil-holding pose that looks common and natural.

Hand Holding a Cell Phone

If there is one hand pose that can be crowned the Definitive Hand Pose of Our Time, it is surely this one. Everywhere you turn today you see a person holding a cell phone. You are likely to see several of them at once (assuming you aren't too busy staring at a cell phone yourself!). So it's no surprise that artists are called upon to draw this pose quite frequently. Follow this lesson to see how it's done.

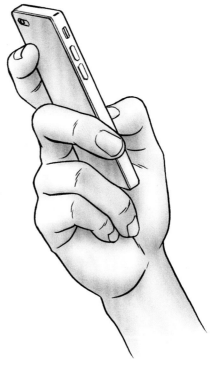

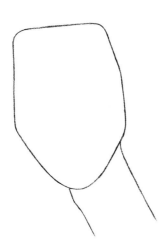

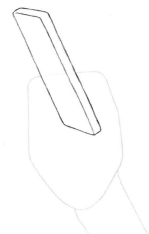

1 The Palm and Wrist

Begin by drawing the palm shape. In this case it is a sort of modified pentagon: five sides with rounded corners. Next draw the wrist, making its contour lines parallel to each other and with a diagonal tilt. That little bump over on the left-hand side? You guessed it. The ulnar styloid process.

2 The Cell Phone

As was the case with the pencil pose, it's best to get the cell phone in place before adding the fingers in around it. When you draw the shape of the cell phone, pay attention to its angle and its location within the area of the palm. Its bottom contour line is pretty close to the dead center.

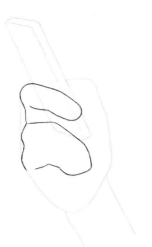

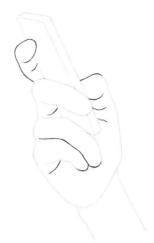

The Finger Guidelines

This pose requires us to skip the index finger for now and to draw a few guidelines for the three remaining fingers. The highest of the three is the middle finger, upon which the cell phone rests. Draw it so that its knuckle rests in the corner of the palm shape you drew in step 1. Then add a single curving mittenlike shape for the ring finger and pinky.

Index Finger and Thumb

Now you can draw the index finger, tilted up and away from the other fingers so as to support the top of the cell phone. Like all the fingers in this pose, it is bent at both its joints, so as to maintain a tight grip. Add the thumb on the other side of the phone, bent inward so as to touch the screen. Finally, draw a curving line that separates the ring finger from the pinky.

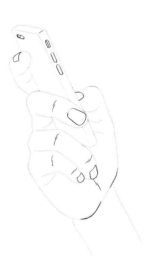

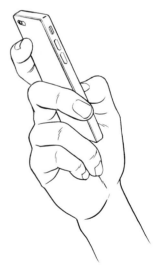

The Details

Having got the fundamentals of the pose in place, you can move on to the details. This pose is demanding in terms of the fingernails. You must draw them from several different angles, depending on the angle of the finger. Lines across the knuckles of each finger help to show their structure. Without them, the fingers look a little formless.

The Finished Drawing

There are probably unwanted guidelines left over from steps 1 and 2, so you'll need to carefully erase them. As always, there are as many different ways of holding a cell phone as there are people holding them. But this is a good starting point for anyone wanting to commit such a pose to memory.

Hands Holding High-Tech Devices

Cell phones are far from the only tech items people are operating these days. Here are some illustrations that can help you understand what people's hands look like when they're holding other common tech objects.

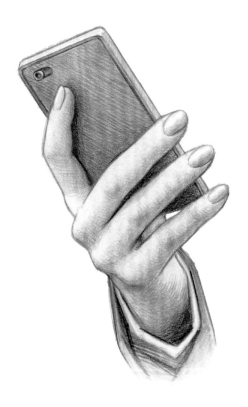

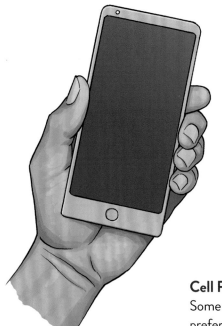

Cell Phones
Some people maintain a tight grip on their cell phones, while others prefer a lighter touch. Unless the phone is unusually small, the index finger rarely reaches to the very top of the device.

Keyboard
When typing on a keyboard, a person's fingers tend to be gently curved. The joints of the fingers are bent, but only just slightly. The thumb stays more or less straight.

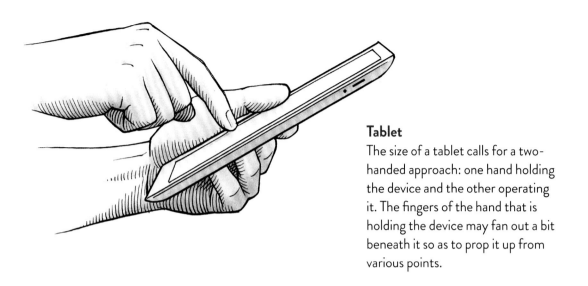

Tablet

The size of a tablet calls for a two-handed approach: one hand holding the device and the other operating it. The fingers of the hand that is holding the device may fan out a bit beneath it so as to prop it up from various points.

Remote Controls

When you draw someone holding a remote control, try to have the bottom of the device rest in the hollow of the palm. Most remotes are small enough that the fingers can wrap all the way around them to the other side.

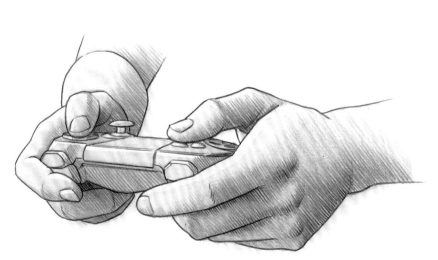

Video Game Controller

When drawing someone operating a video game controller such as this one, remember that only the thumbs and index fingers are needed for the main operations. The other three fingers on both hands bend under the controller and stay out of the way.

Cooking and Eating

When I decided to do a chapter devoted to hands performing daily tasks, I knew that the topic of cooking and eating was a must. No matter what kind of illustrator you are, you will eventually need to do a drawing involving people preparing and consuming food. As you might expect, the hand poses related to such activities are not always easy to draw. Here are some tips.

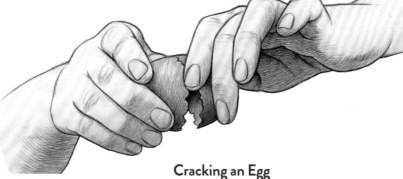

Cracking an Egg
When people perform a delicate task like cracking an egg, their hands adopt poses that reflect the precision needed for the job. Very often the ring finger and pinky don't even touch the object being held, and they may be raised up a bit to stay out of the way.

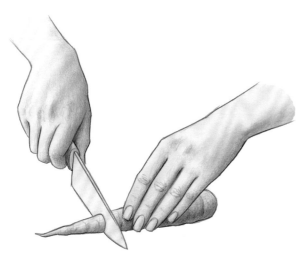

Slicing Vegetables
This sort of pose requires drawing two very different hand poses. The knife-holding hand is drawn with prominent knuckles, its fingers tensed and gripping the handle firmly. The hand that holds the vegetable in place can have a much more relaxed look to it.

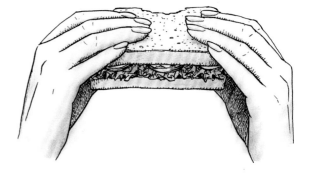

Holding a Sandwich
This is a good example of symmetry in a hand pose, the two hands mirroring each other perfectly. Note how the relative length of the four fingers is on display in this pose. The middle finger being longest, followed by the index and ring fingers, followed by the pinky.

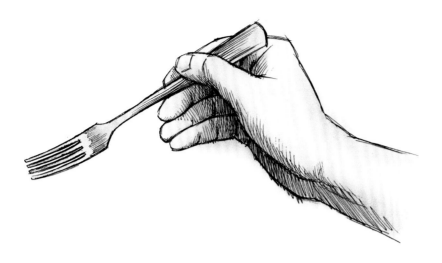

Holding a Fork

Many tasks related to eating and drinking involve the hands wielding silverware of some kind, so artists need to pay attention to what these hand poses look like. While a toddler might grab a fork using her entire fist, a grown-up has learned to rely mostly on the thumb and index finger.

Stirring with a Spoon

Here's another example of a hand holding a utensil. The thumb and index finger maintain a light grip on the handle of the spoon, while the other three fingers curve gently away. In such cases the pinky often curves farther away, tilting at a slightly different angle from the others.

Holding a Paper Cup

In the age of Starbucks, this pose has become very common indeed! Paper cups are generally made to be the perfect size for a human hand, with enough space for all four fingers to rest along the side. People tend to separate their fingers a bit when holding such a cup, allowing a little breathing room between each finger.

Holding Scissors

Some hand poses are simple enough that you can memorize them without too much trouble. Others are highly specific and will leave you scratching your head when you try to draw them from memory. A hand holding a pair of scissors is one such pose. You're bound to do an awful lot of erasing as you try to figure out the exact location of each finger. Follow this step-by-step lesson to see how it's done.

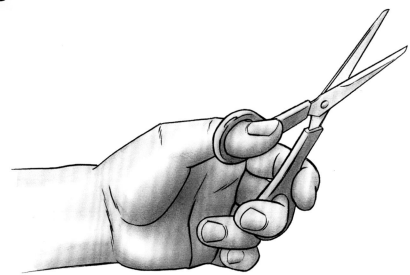

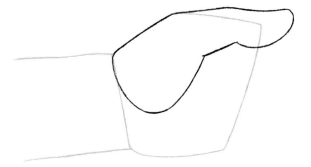

1 The Palm and Wrist
Begin with a basic guideline shape for the palm. In this pose, it is a sort of lopsided pentagon. Then draw two lines on the left-hand side to serve as the wrist. Note how the bottom contour line of the palm shape curves slightly as it reaches the lower line of the wrist.

2 The Thumb
When seen from this angle, the thumb joins with the base of the palm to form a single three-part shape. When drawing this shape, pay attention to its size relative to the palm shape and also to its angle relative to that of the wrist. Note how the tip of the thumb curves up and away from the palm.

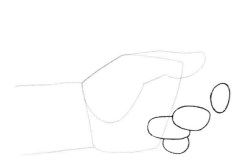

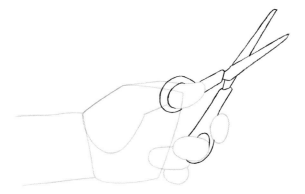

The Finger Guidelines

Now we get to the tricky part: the position of the fingers. You need to draw just the fingertips at this stage, rendering them as small oval shapes. If you start with the ring finger, which overlaps the palm shape, this can help you get all the other fingers in the right location. Take your time. This step requires attention to the size and angle of each shape.

The Scissors

When drawing the scissors, you can relax a bit about the details. There's no need to make it look exactly like the pair of scissors I've drawn here. I'd advise drawing the handles of the scissors first rather than the blades. This way you can focus on getting the handles to line up with the thumb and the middle finger, where they must appear to fit snugly in place.

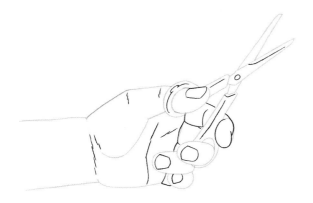

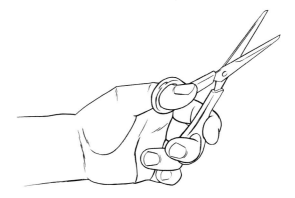

The Fingers and Fingernails

Now it's time to connect the fingertips you drew in step 3 to the shape of the palm. Begin by drawing the bottom two thirds of the index finger, visible through the gap between the two scissor handles. Then move on to the corresponding parts of the middle finger, the ring finger and the pinky. Finally, draw the fingernails and the thumbnail, as well as a few structural lines in the area of the palm.

The Finished Drawing

If there are any unwanted guidelines still visible from steps 1 and 2, go ahead and erase them now. Pat yourself on the back, my friend. You have completed what is arguably the most challenging pose in the whole book.

Reading and Writing

There's no denying we live in the age of smartphones and tablets. But that doesn't mean that books have vanished from our lives forever. When you want to draw a person reading something the old-fashioned way, you will definitely need to know what a book-holding hand pose looks like.

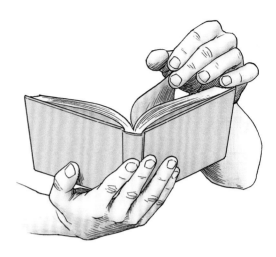

Turning the Page
When a person turns the page of a book, we end up seeing two very different hand poses at once. The hand holding the book needs to be open-palmed and relatively flat, with the thumb on one side of the book's spine, and the fingers heading toward the other. The page-turning hand is more delicate, the ring finger and pinky often raised up a bit to stay out of the way.

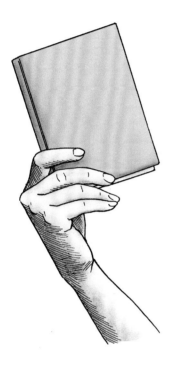

Holding a Book with One Hand
You may need to draw a character holding a book with just one hand so that they might gesture with the other. In this case the thumb goes into the middle of the book, dividing its pages into two halves, while the rest of the fingers wrap around the spine.

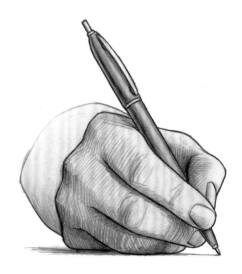

Writing
Refer back to the "Hand Holding a Pencil" lesson on page 102. Sometimes you need to draw that same pose from this angle, in which the hand looks drastically different. Note that the pinky folds so far under the other fingers that only a small portion of it remains visible.

Playing Musical Instruments

When people play musical instruments, their hands naturally need to adopt highly specific poses. Here are three examples, along with a few drawing tips related to each.

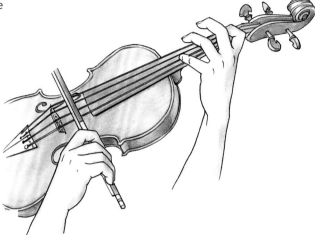

Violin

The two hands of a violin player adopt different poses. The hand that holds the bow is relaxed-looking, with the index finger raised a touch higher than the other three fingers. The hand on the strings is much more tensed. Its fingers often need to press down, simultaneously, in locations that are far apart, pushing the fingers' flexibility to their limits.

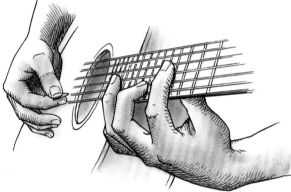

Guitar

Guitar players also present the artist with two very different hand poses to draw. The hand holding the pick is all about the thumb and the index finger, the other fingers hanging loosely out of the way. The hand on the strings is much like that of the violin player: its fingers bending and stretching to reach many different places at once.

Piano

The hands of someone playing piano bear many similarities to those of a person typing at a keyboard (see page 106). The fingers tend to bend into gentle curves, with the resting fingers raised a bit to stay out of the way.

Holding a Baseball

Nearly every sport involves the athletes using their hands, whether they are gripping gold clubs or throwing javelins. (Well, okay, apart from soccer!) But few athletes rely on their hands quite so dramatically as a baseball pitcher. So I thought a pitcher holding a baseball would be a suitable subject for this chapter's one sports-related lesson.

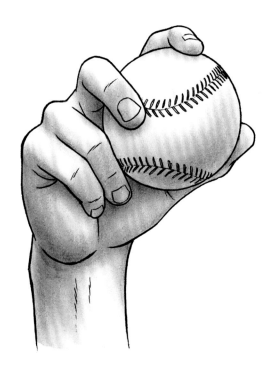

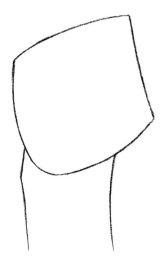

The Palm and Wrist

Begin by drawing the basic shape of the palm. This time it is very close to a square shape, with the lower left-hand corner rounded off. Note that it is slightly wider than it is tall. When drawing the contour lines of the wrist, add in a slight protrusion on the left-hand side to represent the ulnar styloid process.

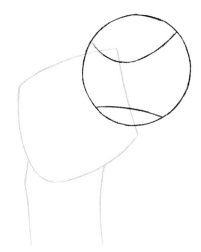

The Baseball

Now draw the baseball, taking care to have it overlap the upper right-hand corner of the palm shape. To get the placement right, try focusing on how much of the baseball is intersected by the right-hand contour of the palm. The overlap area accounts for around 30 percent of the diameter of the circle.

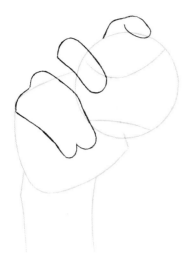

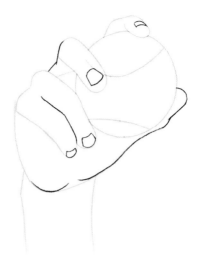

The Fingers

Draw shapes for the four fingers, starting with a single shape for both the ring finger and the pinky. Pay attention to the angle of this shape and how it just barely overlaps the contour of the baseball. Then draw the middle finger and the index finger. Note that the middle finger is parallel to the other two fingers, while the index finger points away to the right.

The Thumb and Fingernails

Draw the thumb. In this pose it is partially obscured by the baseball and can be rendered with a single line that starts down at the base of the palm. As always, the fingernail shapes have to be coordinated with the direction of the various fingertips. In the case of the index finger, we see the fingernail from below, causing it to appear more curved than the other nails.

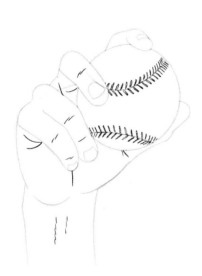

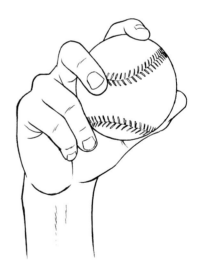

The Details

Add details to finish off the drawing. Short lines across the knuckles of the middle finger, ring finger and pinky help to define the structure. When a hand grips a baseball, it forms wrinkles in the area where the pinky joins the palm, as well as at the base of the thumb. When drawing the threads of the baseball, remember that the lines need to follow along with the curved surface of the ball.

The Finished Drawing

Erase any guidelines that remain from steps 1 and 2. Of course, every pitcher has a unique way of holding a baseball, and some of them no doubt look very different from what you see here. But they all have one thing in common. The pitchers are gripping that thing like their careers depend on it. Because, let's face it, they do!

Sports

The truth is you could fill an entire book like this with nothing but hand poses related to all the various sports and leisure activities out there. But here are three common ones that I think deserve a closer look.

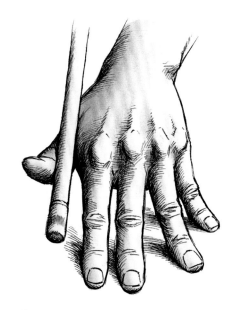

Playing Pool

When people play pool they need to transform one of their hands into a pose that is entirely unique in the world of sports. When drawing this pose, you must make sure that the hand appears tensed: its tendons visible and its fingers pressing down firmly upon the table.

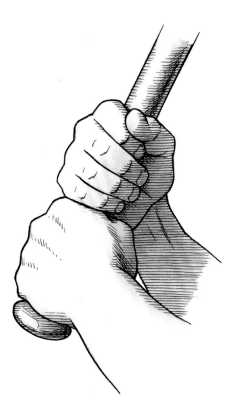

Gripping a Baseball Bat

When you draw someone holding a baseball bat, place the lower hand against the very bottom of the bat, and the upper hand immediately atop the lower hand. Note that the thumb locks down upon the index finger while also resting against the bat.

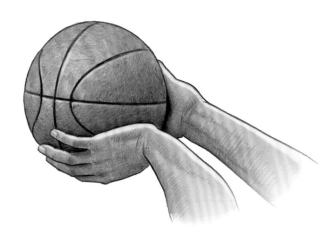

Shooting a Basketball

Compared to these other two poses, the hands of someone shooting a basket appear much more relaxed. One hand is below the ball, providing most of the thrust, while the other hand is on the side of the ball, holding it in place and steadying it.

Driving Cars and Riding Bikes

Illustrators and cartoonists are often called upon to draw people driving cars. While it may seem like an easy enough task, the actual particulars of drawing the hands can prove surprisingly tricky. Here are some tips along with advice on drawing hands on a bicycle's handlebars.

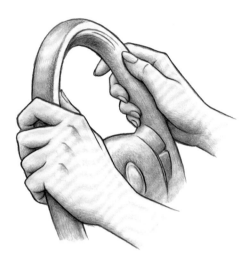

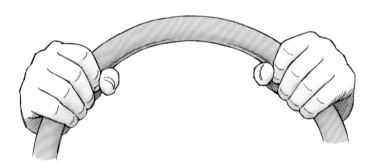

View from the Front
When drawing the hands from this point of view, note that the knuckles are visible in the upper contour lines of each hand. The lines that delineate the individual fingers come to a stop well before reaching that contour line. The thumbs are foreshortened, pointing almost directly toward the viewer.

View from the Side
Use a more relaxed grip when drawing the steering wheel from the side. The thumb of each hand rests upon the upper surface of the wheel, while the fingers wrap around to grip the lower surface. For a truly relaxed-looking pose, allow the index finger to let go of the wheel a bit while the remaining fingers hold firm.

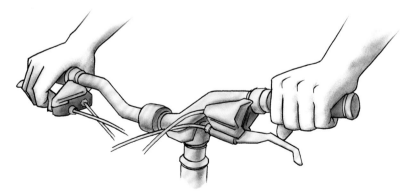

Riding a Bike
When a person rides a bicycle, the surface of the back of the hand goes horizontal as all four fingers fold down and around the handles. To convey the look of a tight grip, add little lines emphasizing each knuckle.

Holding a Sword

Though the sword is often regarded as a weapon from the past, it remains popular today among illustrators and creators of fantasy stories. Drawing a hand holding a sword can be a stumbling block for many artists. It can be a struggle to get the fingers to look like they're really closed around the grip. Follow this lesson to conquer this crucial hand pose once and for all.

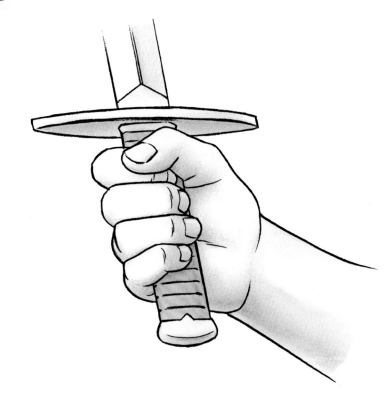

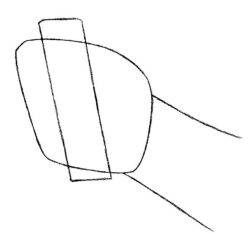

1 The Palm, Wrist and Sword Grip

To begin, draw the shape of the palm, which in this pose is a modified square: wider at the top than at the bottom and rounded on the upper and lower right-hand corners. Then add the sword grip, a simple rectangular shape. Be careful to place it so that it is closer to the left side of the palm shape than to the right. Finally add two lines for the contours of the wrist.

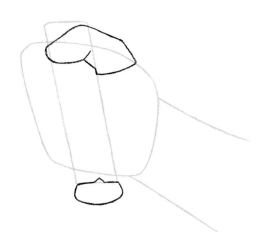

2 The Thumb and Sword Cap

Now draw the thumb, adding it in on top of the upper contour line of the palm. Note that the tip of the thumb extends just past the left-hand side of the sword grip. This is also a good time to add to the sword. I've drawn a simple cap at the bottom, but you could opt for something more elaborate if you like.

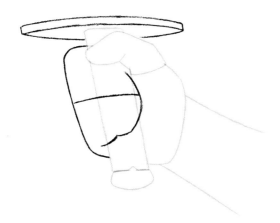

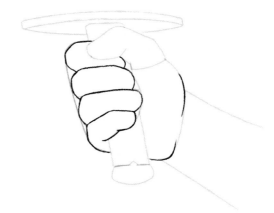

The Finger Guidelines and Cross Guard

To help with getting the fingers in the right place, let's draw a mittenlike shape along the left-hand side of the palm. This shape needs to extend just past the right-hand side of the sword grip. A horizontal line across the middle of this shape will help with finger placement in the next step. Continue adding to the sword, this time drawing a cross guard on the top of the grip.

The Fingers

Using the mitten shape as your guide, add in the four fingers, starting with the pinky and working your way toward the index finger. It's very important to pay attention to the angle of each finger. The pinky is tilting up diagonally toward the upper right-hand side of the image, while the index finger is perfectly horizontal. The other two fingers occupy transitional angles between these two extremes.

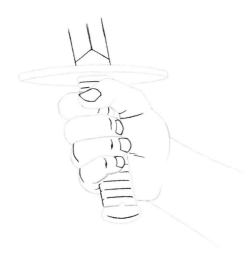

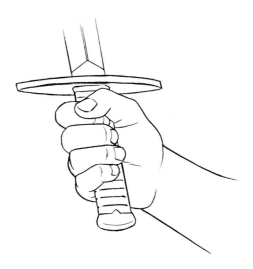

The Details

Now that you have the fundamental structure in place, you can turn your attention to the details. Draw some short curved lines across the knuckles so as to show how the fingers are bent around the sword grip. Add a couple wrinkles into the area where the base of the thumb joins the palm. And, if you like, add more details to the sword.

The Finished Drawing

Erase any guidelines you can still see from steps 1 and 3. Next time you need to draw a character wielding a sword, you know what to do: come back to this lesson and follow these steps. Over time, you will find that you can commit the whole process to memory.

Swords and Daggers

If you're serious about learning how to draw characters holding swords, you're going to want to learn how to draw more than one pose. Here are a few more to help you further expand your drawing abilities in this area.

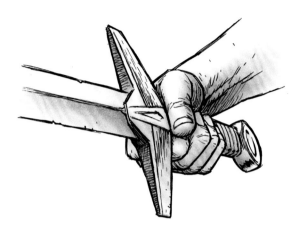

Sword Pointing Forward

When a character lowers the tip of the sword until the blade is nearly horizontal, our view of the hand changes considerably. The thumb points out toward the viewer, and it becomes easier to see how the fingers bend and wrap around the sword grip.

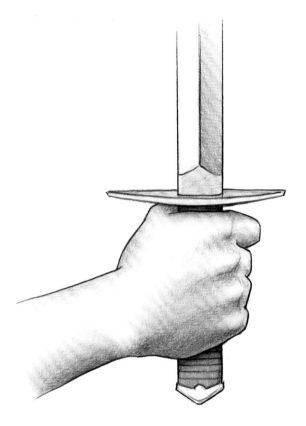

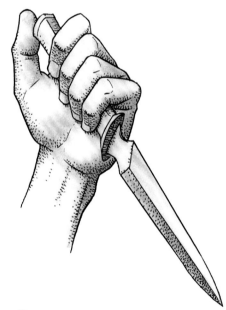

The Back of the Hand

When you view the hand from the other side, the details of the fingers and thumb are hidden from view. You must take care to suggest their presence by way of the contours of the knuckles. Note that the contour of the index finger is more prominent than that of the other fingers.

Gripping a Dagger

A person wielding a dagger may choose to raise it up high, turning the weapon so that the blade points downward. When you draw such a hand pose, you need to focus on the four fingers and how their shapes cascade down the grip. Though the fingers are all parallel to one another, each of them is bent at a slightly different angle.

Daily Tasks

As you continue practicing drawing hands, keep your eyes open for any remaining poses that you haven't tried yet. Any humble daily activity can provide an interesting hand pose that's worth studying. Here are a few to get you started.

Turning a Key

Any task that involves the hand manipulating a small object generally results in the thumb and the index finger stepping up to do the job. The other fingers tend to fold back and stay out of the way.

Holding a Subway Strap

When people have to hold something high above them for a prolonged period of time, they often relax their grip a little, leaving just the tips of the fingers in place. In such a pose the comparatively short length of the pinky becomes very clear.

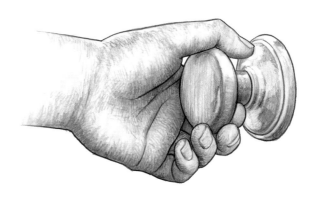

Turning a Doorknob

Turning a doorknob, on the other hand, is going to involve the other fingers getting in on the action. In this drawing, you can see the index finger, the middle finger and the ring finger joining together to maintain the hand's grip.

Holding Hands

For our final step-by-step lesson, I knew there could be only one choice: a pose in which two people are holding hands. It takes us to a new level by including two hands in a single picture. But, more important, it is an image that goes beyond a simple drawing of hands. It projects a message of people joining together, expressing affection and offering each other support.

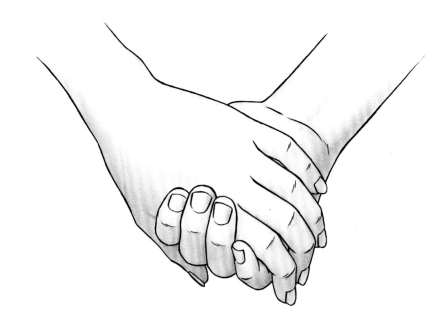

1 The Back of the Hand and Wrist

Let's start with the hand on the left. Once again the back of the hand shape is a modified pentagon. Note that the line on the right-hand side curves slightly. It represents the area where the fingers join the back of the hand. Add two lines on the upper left to serve as the contour lines of the wrist.

2 The Finger Guidelines and Thumb

Draw a mitten shape on the lower right-hand side of the back of the hand. This will help with the placement of the fingers in step 4. When drawing this shape, take care to have it taper as it reaches the tip of the mitten. Now add a line for the thumb. It will be partially obscured later on, so there's no need to draw the whole base of the thumb.

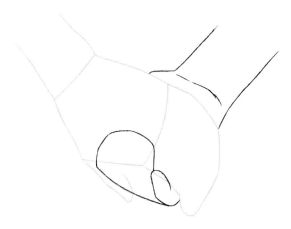

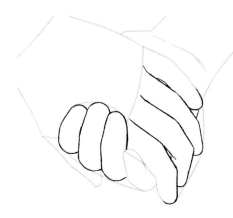

The Guidelines for the Other Hand

Now you can add guidelines for the other hand, beginning with the contours of the wrist on the upper right-hand side of the image. Draw a mittenlike guideline for the fingers, curving around the edge of the first hand's fingers. I've chosen to draw the pinky separately, since it will be pointing in a different direction from the other fingers.

The Fingers

Using the mitten shapes to guide you, draw the fingers of both hands. Note the subtle differences in the angles of each fingertip. If you can capture all these angles in your drawing, the pose will look relaxed and natural.

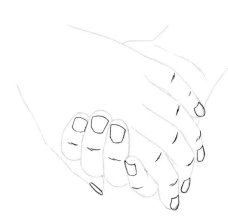

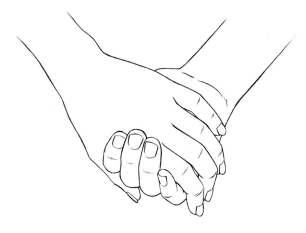

The Details

Add a few final touches. Draw small curved lines across each finger joint to help emphasize the three-part structure of the fingers. Then add the fingernails, making sure to have each nail follow along with the angle of the fingertip it is attached to.

The Finished Drawing

Carefully erase any guidelines that may remain visible from steps 1 through 3. I must say this is probably my favorite hand pose in the whole book. I liked it so much, in fact, that I decided to devote the next two pages to similar poses.

Put Your Hands Together

I wonder if you will find, as I do, that there is an emotional aspect to almost any pose that involves two hands joining together. Simply seeing such a pose gives me a good feeling inside. I would encourage you to try drawing a "hands together" pose if you haven't already. It's a fun challenge, and will result in an exceptional drawing: one you could put on your wall or give as a gift.

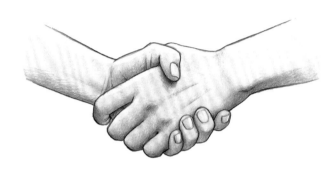

Shaking Hands
When two people shake hands, the pose almost resembles two puzzle pieces fitting together. Owing to the angle of the two hands, the index finger has a greater distance to cover, and ends up appearing shorter than it actually is.

Holding Hands
Here is an alternate version of the hand-holding pose, in which the hand on the left is maintaining a tighter grip. (Compare with the lesson on page 122 to see the differences.)

Fingers Intertwined
A lovely pose but one that can be challenging to draw. You really have to pay attention to the way the fingers overlap one another, keeping the pattern consistent across all ten fingers.

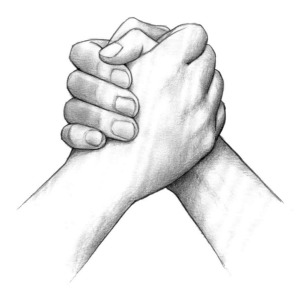

The "Soul" Handshake

This pose can represent two rather different things: a soul handshake or two people arm wrestling! Note that the angle of the wrists allows the index finger to reach much farther than it can in a traditional handshake.

Praying Hands

This pose is highly symmetrical, with each fingertip placed neatly upon the corresponding fingertip from the other hand. When viewed from this angle, you can see how the back of the hand is quite flat, while the palm of the hand is more rounded.

Open Palms

This is a great pose for observing the padded surface of the palms and the areas where wrinkles and creases tend to form. Indeed, the full structure of the hand is plain to see here. The squarish shape of the palm, the two-part structure of the thumbs and the three-part structure of the fingers.

Conclusion

Index

Note: Page numbers in *italics* indicate lessons.

About the Author

MARK CRILLEY is the author and illustrator of more than forty books, including several acclaimed graphic novels, for which he has received fourteen Eisner Award nominations. His work has been featured in *USA Today*, *Entertainment Weekly*, and on CNN Headline News. His popular YouTube videos have been viewed more than 400 million times. He lives in Michigan with his wife, Miki, and children, Matthew and Mio.